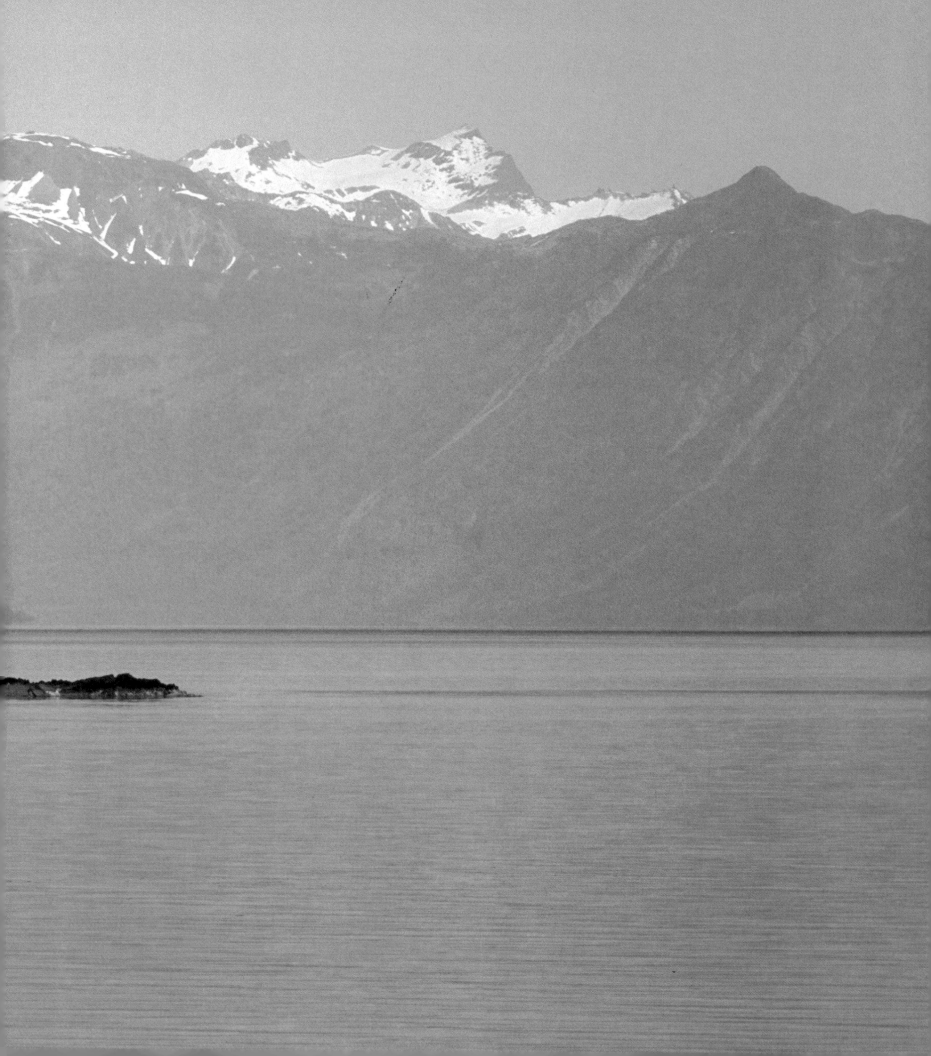

AMERICA

LIFE

HIDDEN
AMERICA

Finding Stunning Beauty and Strange Stories
In Secret Places from Coast to Coast

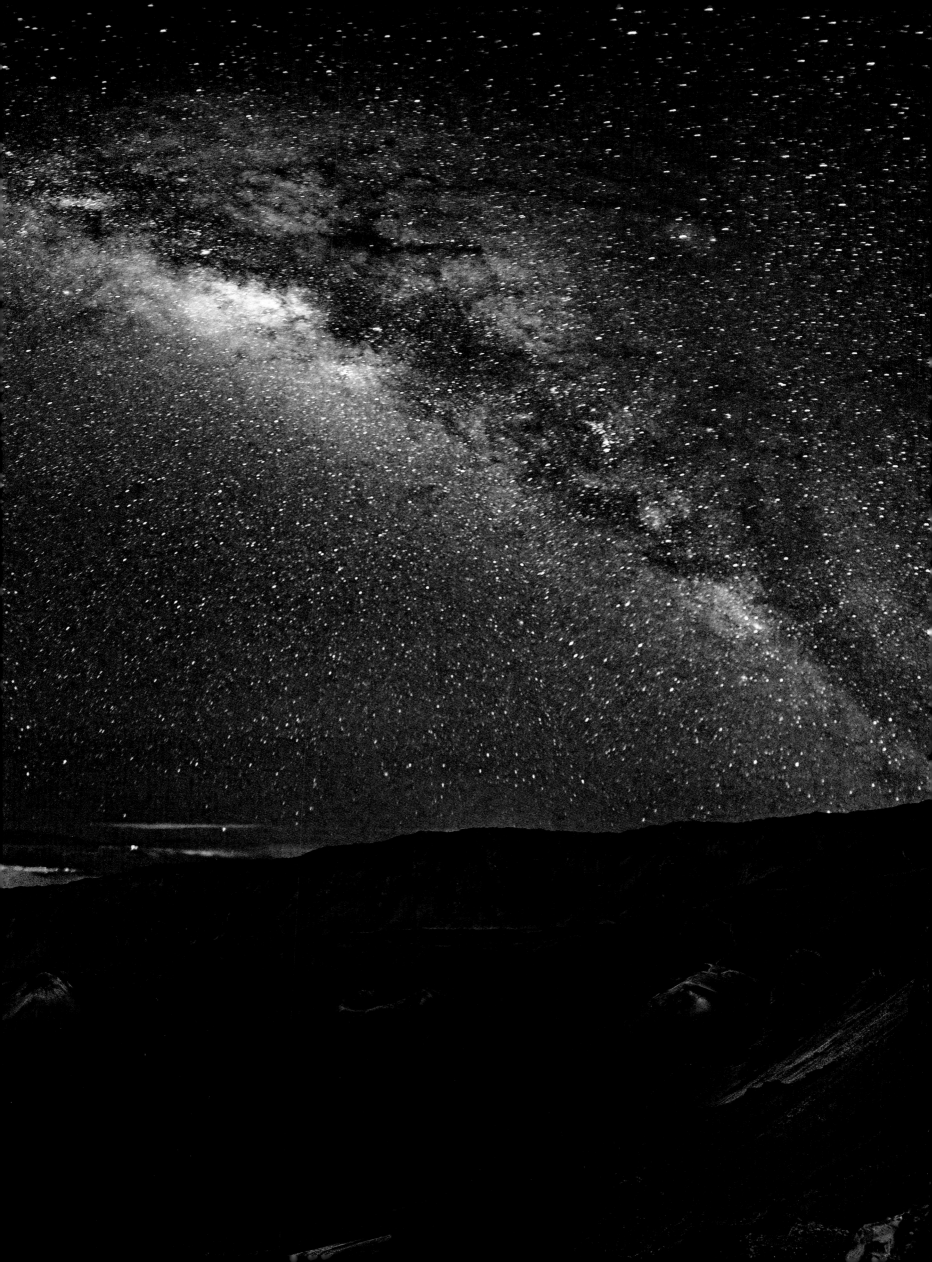

LIFE Books

EDITOR Robert Sullivan
DIRECTOR OF PHOTOGRAPHY Barbara Baker Burrows
CREATIVE DIRECTOR Mimi Park
DEPUTY PICTURE EDITOR Christina Lieberman
WRITER-REPORTER Hildegard Anderson
COPY EDITORS Parlan McGaw (Chief), Barbara Gogan
PHOTO ASSISTANT Forrester Hambrecht
CONSULTING PICTURE EDITORS Mimi Murphy (Rome),
Tala Skari (Paris)

PRESIDENT Andrew Blau
BUSINESS MANAGER Roger Adler
BUSINESS DEVELOPMENT MANAGER Jeff Burak

TIME INC. HOME ENTERTAINMENT
PUBLISHER Richard Fraiman
GENERAL MANAGER Steven Sandonato
EXECUTIVE DIRECTOR, MARKETING SERVICES Carol Pittard
DIRECTOR, RETAIL & SPECIAL SALES Tom Mifsud
DIRECTOR, NEW PRODUCT DEVELOPMENT Peter Harper
ASSISTANT DIRECTOR, NEWSSTAND MARKETING Laura Adam
ASSISTANT DIRECTOR, BRAND MARKETING Joy Butts
ASSOCIATE COUNSEL Helen Wan
SENIOR BRAND MANAGER, TWRS/M Holly Oakes
BOOK PRODUCTION MANAGER Suzanne Janso
DESIGN & PREPRESS MANAGER Anne-Michelle Gallero
BRAND MANAGER Shelley Rescober

EDITORIAL OPERATIONS Richard K. Prue, David Sloan
(Directors), Richard Shaffer (Group Manager), Brian
Fellows, Raphael Joa, Angel Mass, Stanley E. Moyse,
Claudio Muller, Albert Rufino (Managers), Soheila
Asayesh, Keith Aurelio, Charlotte Coco, Osmar
Escalona, Kevin Hart, Norma Jones, Mert Kerimoglu,
Rosalie Khan, Patricia Koh, Marco Lau, Po Fung Ng,
Rudi Papiri, Robert Pizaro, Barry Pribula, Vaune
Trachtman, Paul Tupay, Lionel Vargas, David Weiner

SPECIAL THANKS Glenn Buonocore, Tymothy Byers,
Susan Chodakiewicz, Margaret Hess, Brynn Joyce,
Robert Marasco, Brooke Reger, Mary Sarro-Waite,
Ilene Schreider, Adriana Tierno, Alex Voznesenskiy

Copyright © 2009 by Time Inc. Home Entertainment

Published by
LIFE Books

Time Inc.
1271 Avenue of the Americas
New York, New York 10020

ISBN 10: 1-60320-064-9
ISBN 13: 978-1-60320-064-6
Library of Congress #: 2008911808

"LIFE" is a trademark of Time Inc.

We welcome your comments and suggestions
about LIFE Books.
Please write to us at:
LIFE Books
Attention: Book Editors
PO Box 11016
Des Moines, IA 50336-1016

If you would like to order any of our hardcover
Collector's Edition books,
please call us at 1-800-327-6388
(Monday through Friday, 7:00 a.m.–8:00 p.m.
or Saturday, 7:00 a.m.–6:00 p.m. Central Time).

Coming Soon: **LIFE.com**

GOOD NEWS: LIFE.com launches this spring. Simply put,
it will be the most amazing collection of professional pho-
tography on the Web, with millions of iconic images from
LIFE magazine's archives, never-before-seen LIFE pic-
tures and up-to-the-minute news photos. LIFE.com—
the perfect way to explore your world.

ENDPAPERS: Lynn Canal, Haines, Alaska
RICH REID/NATIONAL GEOGRAPHIC

PAGE 1: Plum Island, Massachussetts
ED KARJALA

PAGE 2–3: Haleakala National Park, Hawaii
WALLY PACHOLKA

THIS PAGE: Bodie, California
CORBIS

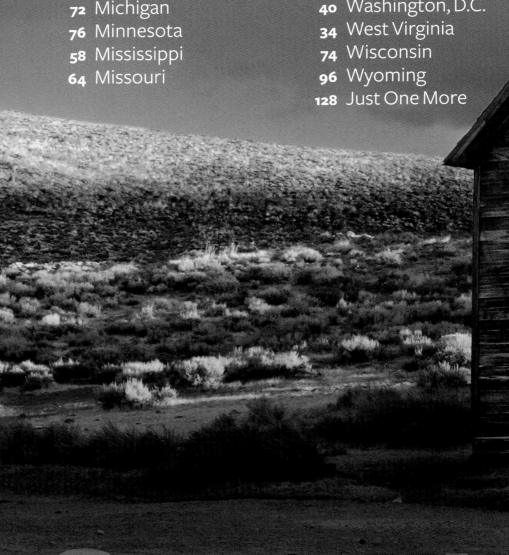

Contents

Seek and Ye Shall Find

Few things are more delightful to the traveler (whether of the actual or armchair variety) than coming upon the unexpected place, the hidden gem, the spot that you can have pretty much all to yourself. This is a book of such places. Some of them have been overlooked, some are a bit harder to get to than others might be, some are quirky or downright odd, and some have simply been forgotten—they enjoyed a heyday once upon a time, and now that day is past.

But all of them are worth discovering or rediscovering. All of them are worth a visit—whether in person, or in these pages.

We travel to each of the 50 states (plus the nation's capital) in *Hidden America*, unearthing scenic splendors that have been neglected and historical sites that have been all but plowed over. There are kitschy roadside attractions here, and grandiose homages that border on the bizarre.

Have you visited the Parthenon?

Oh, you have.

In *Nashville*?

We will take you to hidden rooms where escaped slaves once eluded capture and ghost towns where gunfights erupted on Main Street. We will visit spooky graveyards and sun-splashed beaches. We will tell you of mysteries that may never be solved. Which natives of long ago built these earthen mounds? Where is Blackbeard's treasure buried? Why are all those kangaroos hopping around in Georgia, and why is there a pyramid in the middle of nowhere in Wyoming?

There are degrees of hiddenness in this world of ours and, to be sure, none of these places is truly hidden. They exist, even if the stories that some of them tell are uncertain or at least cryptic.

But often these places are known only to the locals, and go uncelebrated in books intended for a wider audience. Many folks in eastern Massachusetts can tell you about Plum Island or Cuttyhunk and about how they're great for a visit—just as great, if not more so, than Nantucket or Martha's Vineyard. But outside the Bay State, these "other islands" might come as a surprise—or, at least, we hope they do.

So the criteria for what constitutes "hidden" is more elastic than precise. Our aim here was for a lively, eclectic collection of fascinating, often beautiful sites from sea to shining sea. We hope we have hit our mark.

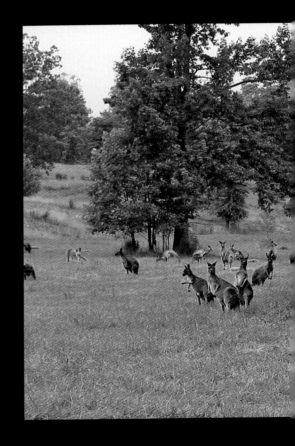

We hope, too, that our book inspires you to seek out some of these places. You won't be able to visit Camp David, necessarily—a small few of our entries are, admittedly, off-limits to the normal tourist— but the great majority of destinations in this book are open to you, in season, and are more than ready to welcome you. A bonus for the visitor to a "hidden" place: Your hosts, never overwhelmed, are so happy to see you, and courteous in the extreme.

If the book does not serve as impetus to get up and go, we hope it is nevertheless a pleasure. We have tried to capture, in words and pictures, the essence of each site. We want to take you to these places as soon as you turn the page.

And so, please do turn the page.

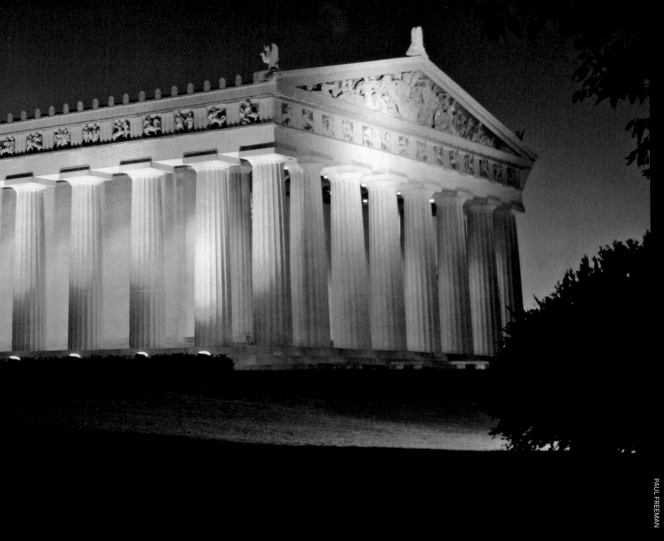

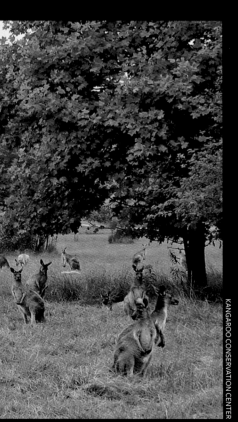

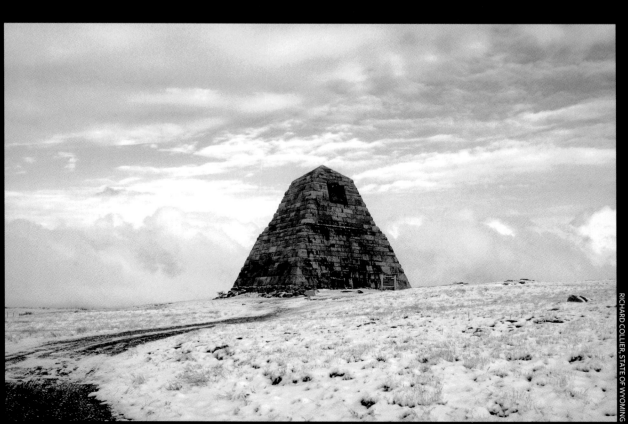

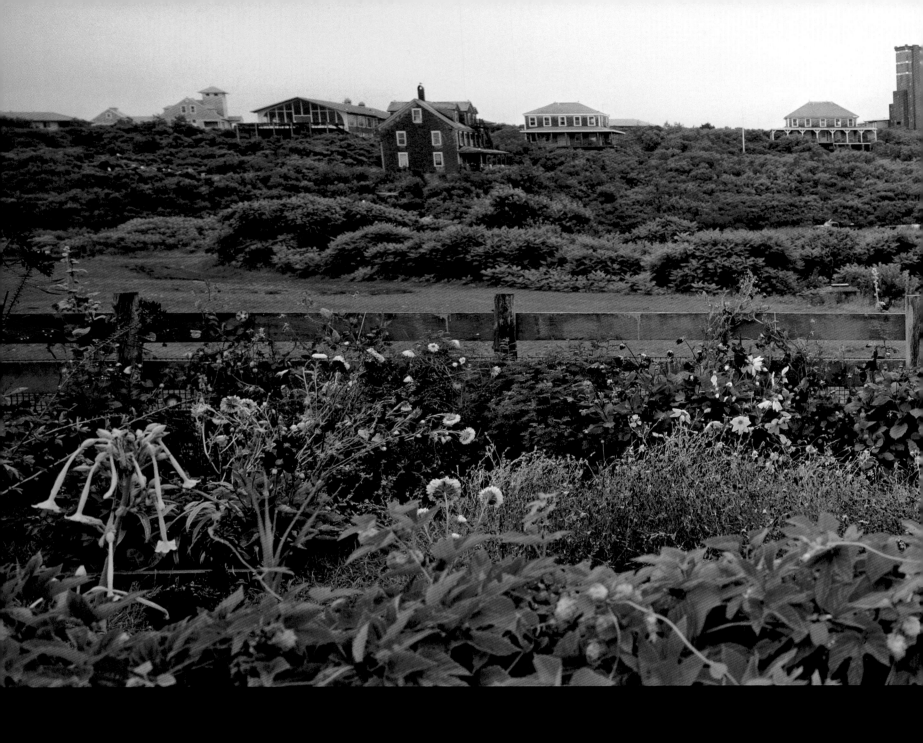

A Secret Garden

Down-Easters are proud of their islands—Mount Desert, with its splendid Acadia National Park; tiny Vinalhaven, made famous by the writings of favorite daughter Linda Greenlaw; and a hundred others. But mention the island of **Appledore** to even the sagest State o' Mainers and you might get some quizzical responses. Many wouldn't know what you were talking about, and those who did would wonder why on earth you were asking after Appledore.

It is the largest of the nine Isles of Shoals, which are located 10 miles off the coasts of New Hampshire and Maine and split between those two states. Today, Appledore, about a mile long from east to west and just over half a mile north to south, is home to a marine laboratory and not much else.

Well, there is the garden. And a splendid, vibrant garden it is. Pilgrims must make a great effort to visit it, taking the steamship ferry from Portsmouth in New Hampshire out to neighboring Star Island, then a second leg to Appledore

aboard the research vessel *Kingsbury.* They clamber onto the island and hoof it along a dirt road to the garden, where they are transported into the past.

How so?

Well, Appledore wasn't always a ghost island, not hardly. It was first incorporated as Hog Island back in the 1660s and experienced true glory days during the Gilded Age of the 1800s. The Appledore House hotel had been built in 1847 and in the latter half of the 19th century was a focal point of a salon presided over by Celia Thaxter, America's most popular female poet in that era. Nathaniel Hawthorne visited Thaxter on the island; the celebrated pianist William Mason played the grand piano for her daily; the famed artist Childe Hassam painted her magnificent garden, the re-creation of which (above) is kept up by Thaxter devotees to this day. Celia died in 1894, the Appledore House burned in 1914—and the mists of time erased much that was once wonderful on Appledore Island.

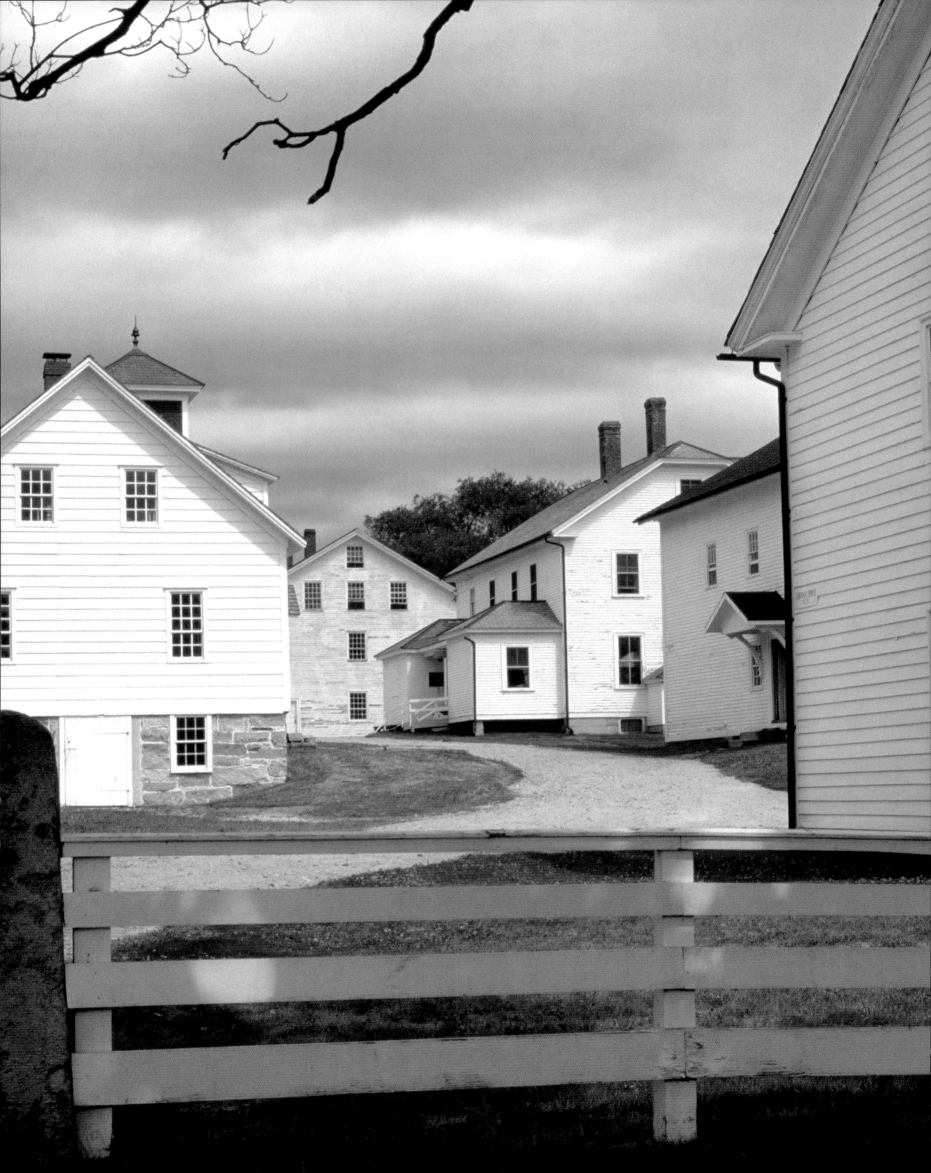

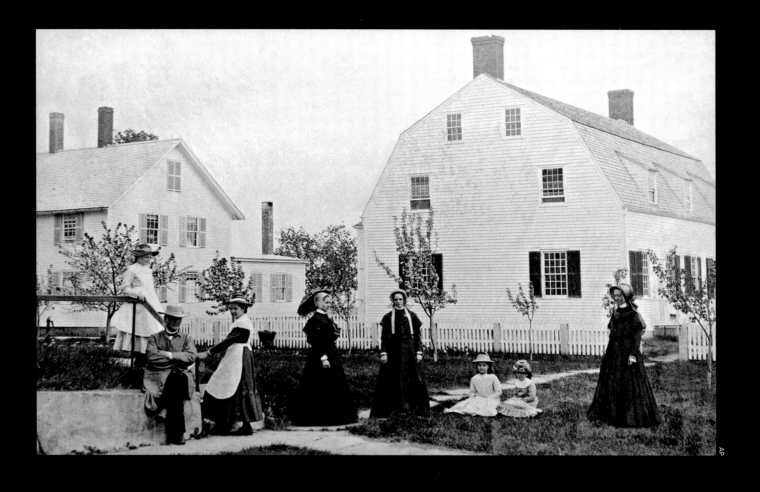

Heart in Hand

Formally, these Protestants called themselves the United Society of Believers in Christ's Second Appearing, but to the rest of the world they were the Shakers, a more physically demonstrative 18th-century offshoot of the 17th-century Quakers. Their religion was born in England in 1747 and had been exported to the United States by the end of the century, with Shaker communities established in New York, Connecticut, Massachusetts, New Hampshire and Maine. In these villages, men and women did everything separately but equally; they shared the work even as they used different staircases and doors, and sat with their own sex on opposite sides of the room. Their philosophy was lean and clean: "Hands to work, heart to God," as represented in their heart-in-hand symbol. Because they were chaste by church law, their population grew only through conversion and the adoption of orphans (and was doomed to dwindle when the United States outlawed adoption by church groups in 1960). The Shakers proved to be brilliant designers and architects, and their style and craftsmanship, with its hallmark simplicity, remains in vogue today.

The Shaker community at Sabbathday Lake, Maine, is still inhabited by four converts to the religion, but the other 18 major Shaker enclaves in the U.S. are defunct. Or, at least, defunct in the sense that there are no longer Shakers on the premises. But many of the buildings remain, nowhere more splendidly than at the historic site that is **Canterbury Shaker Village**, just outside New Hampshire's capital city, Concord. Twenty-five of the original structures, which date as far back as the community's founding in 1792, have been restored, while four others have been reconstructed. Forests and ponds distinguish the 694 idyllic acres, and a real sense of life as a Shaker (above, in front of the Meeting House, circa 1888) can be had during a visit. The fine Shaker Table restaurant in the renovated blacksmith shop boasts Shaker-inspired fare, but it must be asked: What would the movement's founder, Mother Ann, have had to say about a $48 Gorgonzola-encrusted pan-roasted local veal chop with rum-macerated plums?

The Hills Are Alive

Yes, they are indeed, but these aren't *those* hills—the ones surrounding famous Stowe, where the famous von Trapp Family Singers of *The Sound of Music* settled after World War II and opened a now-famous inn. Nor are they the famous hills farther south—Killington, Stratton, Mount Snow—that are the objects of desire for much of New York City's skiing set.

The hills we refer to are those of the **Mad River Valley**; these are situated pretty much in the middle of the state and are too often overlooked by visitors seeking the essence of the Green Mountain State. They give no quarter to any other New England hills when it comes to sublime beauty, and they are enjoyable in any season.

The green waters of the Mad River can be kayaked or fished for brown, brook or rainbow trout, but a true treat in midsummer is to bathe there. Swimming holes—the Great Eddy, the Lareau, the Greenway, Ward's and, for nudists, the Punch Bowl—dot the area and lure Huck Finns of all ages. Some of the finest hiking to be had begins in this valley; a trip up Camel's Hump during fall foliage season is literally and metaphorically a breathtaking experience.

In winter, this being Vermont, there is skiing. Sugarbush (seen here) is a terrific, large, modern resort, while Mad River Glen is a terrific, challenging, antimodern ski area—as funky and fun as any in the land. Its trails and glades are spectacular in a good snow year and downright scary in a bad one. Mad River Glen is resolutely retro; it prohibits snowboarders and even has a single-chair lift to the summit. This is not a place for snow bunnies but for serious schussers (its motto is "Ski it if you can"). Yet, for all of its recalcitrant crankiness, the Glen is oddly lovable.

Vermont

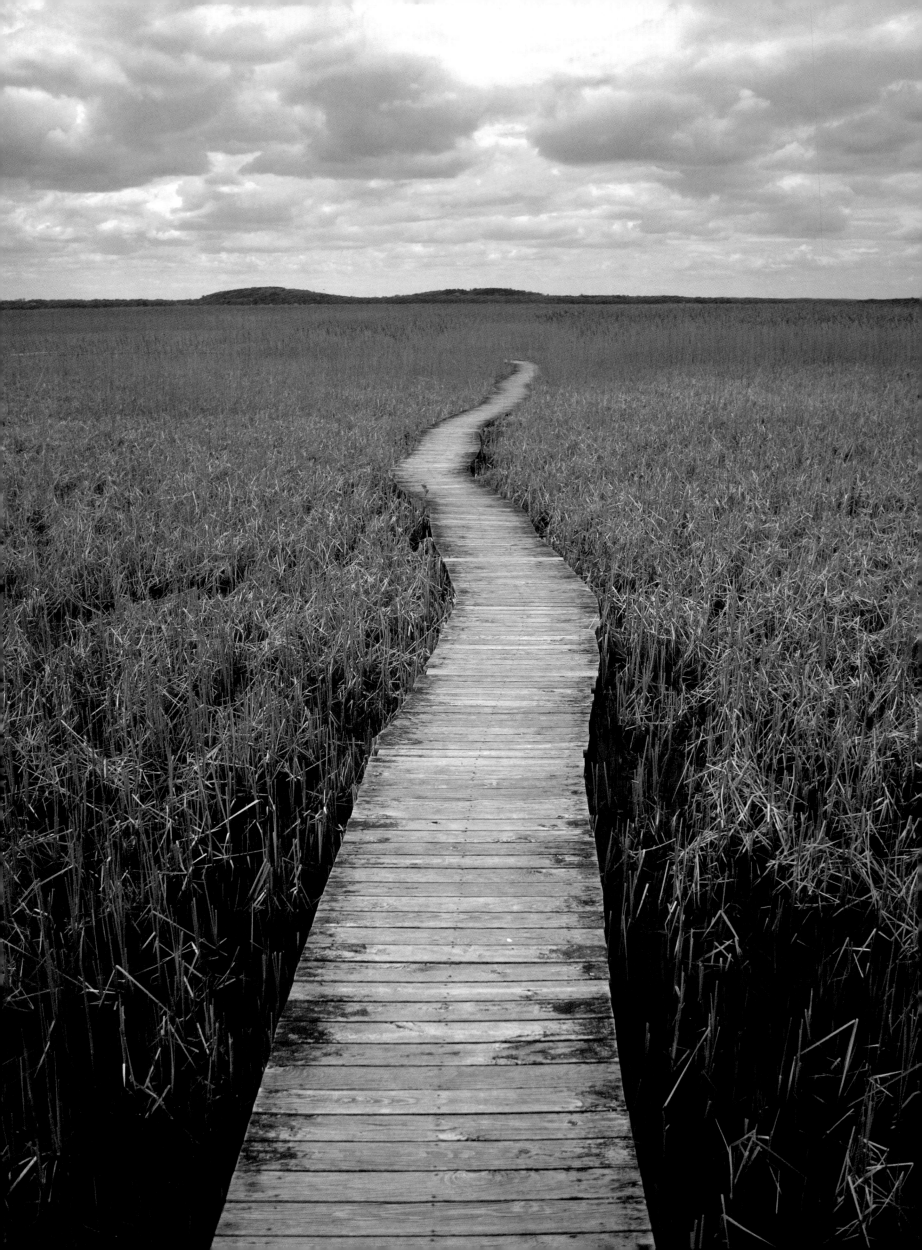

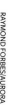

The Bay State's Other Isles

As everyone knows, Boston Brahmins and others of the Massachusetts aristocracy choose to summer (used here as a verb) on the properly zip-coded islands of Nantucket and Martha's Vineyard. Meantime, whither the hoi polloi? Well, among other places, they shuffle off to **Plum Island** and **Cuttyhunk**, two less well known (but hardly lesser) isles, the former just off the state's northeastern coast and the latter 14 miles off the southern mainland.

Plum Island (opposite) was vividly described by one Joshua Coffin in 1845 when he wrote of "a wild and fantastical sand beach . . . thrown up by the joint power of winds and waves into the thousand wanton figures of a snow drift." A barrier island 11 miles long, it is today connected to the charming mainland town of Newburyport by a causeway. Dunes on the island rise to 50 feet, and sturdy black pines mark the landscape. There are cottages and B&Bs and a dominating national wildlife refuge on the southern end of the island.

Cuttyhunk (above), the westernmost of the Elizabeth Islands chain in Buzzards Bay, is two and a half miles long and less than a mile wide. From its town dock a visitor can look across the sound at much larger and more illustrious Martha's Vineyard—and be glad to be free of the social hubbub. Perhaps 30 people call Cuttyhunk home year-round; even in the summer months the number is only 300. This is a rocky realm, with slopes coated in sumac and bayberry. The wind whistles here all but constantly. When heading for Cuttyhunk, pack your tight-knit Aran sweater, and certainly your L.L. Bean macintosh.

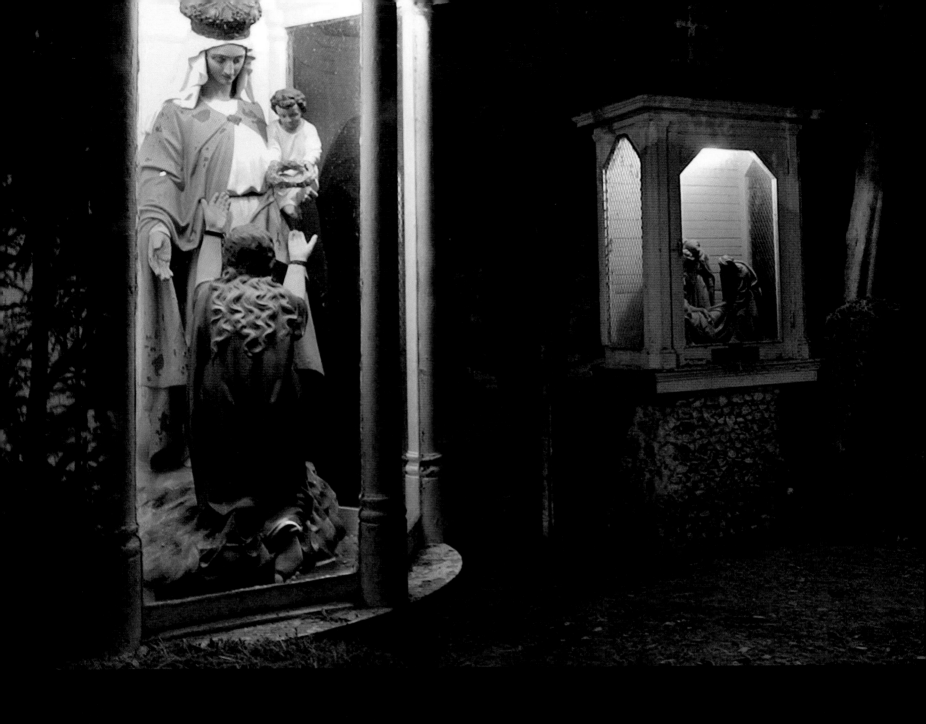

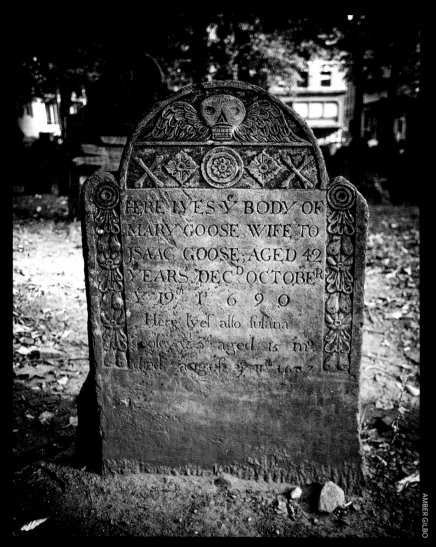

AMBER GILBO

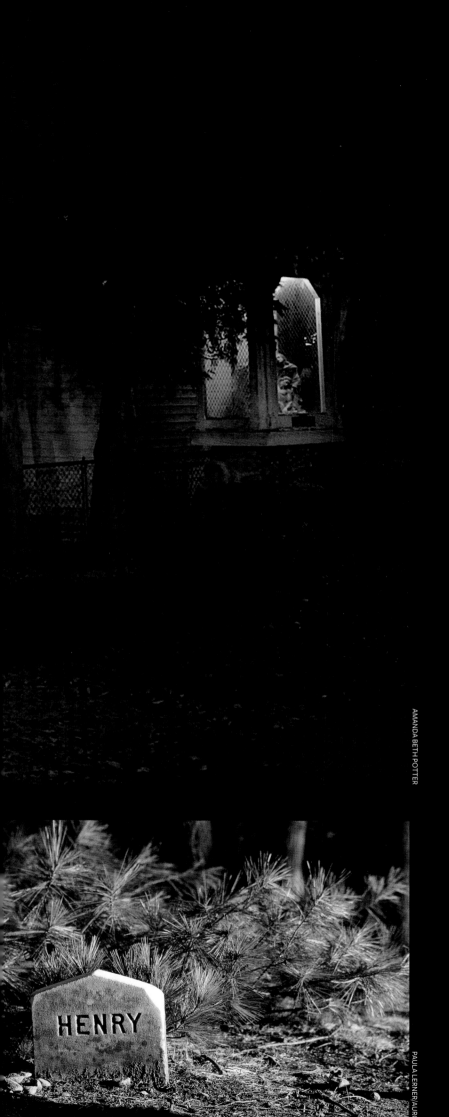

AMANDA BETH POTTER

PAULA LERNER/AURORA

Spirituality

Concord is a town of deep and varied history that does its memorials well. One can stroll across the North Bridge, where once was fired the shot heard round the world that ignited the American Revolution, and imagine Minutemen massing on the hillside back in 1775—with no undue intrusion from signage or multimedia embellishment. One can visit the houses where lived the Alcotts and Emersons, or quaff a pint at the Colonial Inn, which Henry David Thoreau's grandmother ran. One can visit Thoreau's Walden Pond or, even better, his grave on Author's Ridge in the town's **Sleepy Hollow Cemetery**. Perhaps no other American is commemorated more appropriately than is Thoreau with this vigorously simple, stoic, sensible and gentle slab of marble (left, bottom).

On Tremont Street in Boston is the **Granary Burying Ground**, where reside many of the city's (and country's) prominent early leaders and one great literary mystery. A headstone (above) claims that beneath it lies Mary Goose, wife of Isaac Goose, who died in 1690 at age 42. Was she indeed the creator of the Mother Goose rhymes? Some say so. Others cite an Elizabeth Goose—also said to have been married to Isaac—who died in 1758. Are both women buried in the graveyard? Is either? Nothing is sure. And was one the creator of Mother Goose, for certain? That, too, cannot be proved: The real Mother Goose has never stepped forward.

The extraordinary **Grotto of Our Lady of Lourdes** in Lowell is a replica built in 1911 of the one in France that is among the world's great pilgrimage sites. The Lowell version, too, is a magnet for pilgrims—as much for literary reasons as religious. Fans of the beat icon Jack Kerouac trek from all over the world to his hometown each year, and they know that the grotto behind the Franco-American School on Pawtucket Street is where Kerouac's mother took young Jack to pray. He admitted to being creeped out by the stations of the cross there (left, top), and the grotto figured spookily in his novel *Doctor Sax*.

Rhode Island

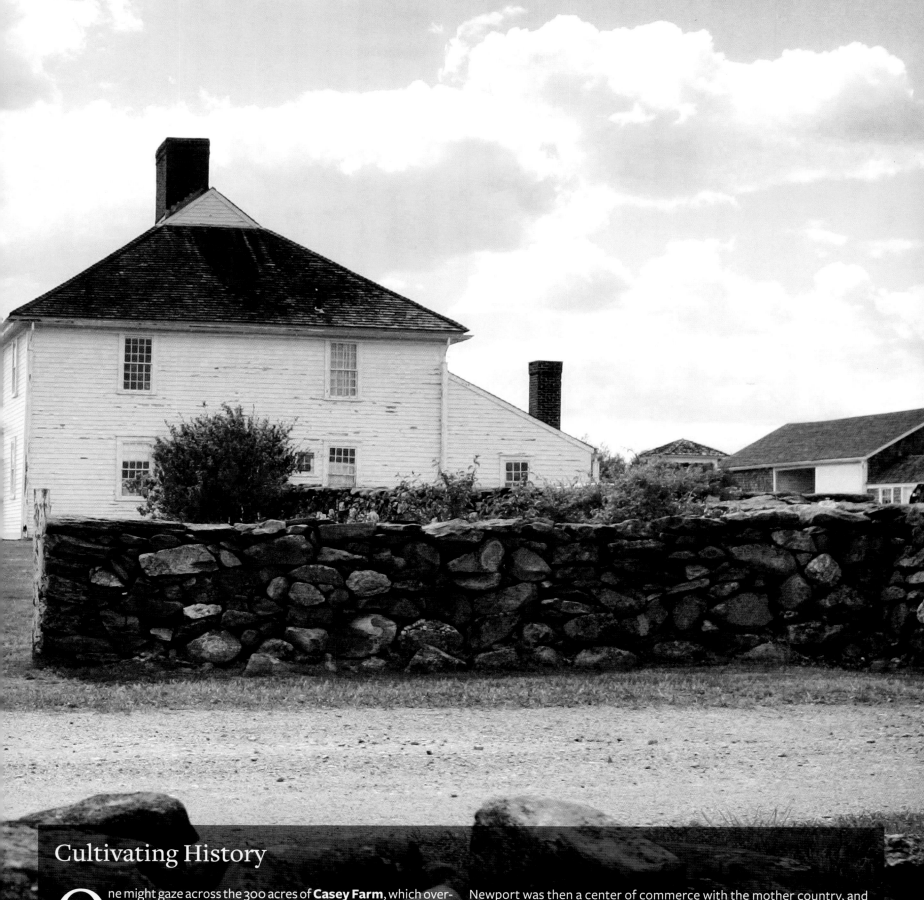

Cultivating History

One might gaze across the 300 acres of **Casey Farm**, which overlooks the sparkling Atlantic in Rhode Island's Narragansett Bay, and see nothing but a thriving modern agricultural operation. Indeed it is that, as resident farm managers oversee the cultivation of organic vegetables, herbs and flowers that are destined for local households through a subscription program. But to see only the daily bustle of contemporary life at Casey Farm is to miss the larger significance of this place. In the soil here is American history. The earliest decades of the farm were an example of pre-Revolution Colonial industry at its finest—an example of our country putting down roots and learning to live on its own.

The land here had already been cultivated for centuries by the Narragansett Indians, and the first half of the 18th century saw the founding of this farm; the impressive gabled homestead dates to around 1750. Casey Farm is a surviving example of a Colonial-era plantation farm, one

Newport was then a center of commerce with the mother country, and the denizens of Casey Farm enjoyed materials and goods imported from England. A measure of the farm's produce was exported in turn. Life and business were good when the American Revolution intervened.

In 1776 the British took Newport, and for much of the next many months Narragansett Bay was essentially one large battlefield. After the war, both Newport and Casey Farm struggled to find their way. It wasn't until the mid-19th century that tenant farmers who leased the land from the Caseys began to bring it back to life.

Today, on any sunny Saturday, hundreds of health-conscious foodies make their way to the farm to buy locally made honey, grass-fed lamb and freshly harvested oysters at the Coastal Growers' Market. The visitors would be edified in a different way by a visit to the old cemetery on the property, where six generations of Caseys rest—and attest, silently, to the

In a Day Before Disney

The Norton family had bought—well, swindled—the serene lake in central Connecticut from Native Americans back in the 1600s, and in 1846 Gad Norton created a path around the lake. He put out some picnic tables, built a gazebo and a few rides, and invited the public in. And so began a 162-season run for America's oldest continuously operating amusement park, **Lake Compounce**.

It is today a stellar family park, with four roller coasters (including the wooden classic, the Wildcat, built in 1927), a host of other attractions and a large water park. Like anything dating back 162 years, it has known boom times and lean times. It has survived not only the tense summers during two world wars but even the terrible days of the nation's Civil War, plus the chilling effects of the Great Depression, when trolley service to the park was discontinued. In the early 1990s, Compounce nearly went under, opening for only a few days in some years to keep its streak alive while its owners looked for a savior. This hero appeared in 1996 in the form of Kennywood Entertainment, already owner of the equally hallowed Kennywood amusement park in Pittsburgh. Kennywood has poured nearly $70 million into Compounce, renovating the Wildcat and building new rides, including the Boulder Dash (seen here), which is routinely rated one of the finest wooden roller coasters in the world. Kennywood has fixed up the train that circles the lake, where once the Tommy Dorsey Orchestra and its young vocalist, Frank Sinatra, drew 5,000 fans. Listen, and you can hear the music playing.

Lake Compounce was the beginning of an idea in America: that a clean park with fun rides and other amusements would be just the place for a family to go on a Saturday afternoon. The Disneylands and Universals and Great Adventures of our entertainment landscape may have taken that notion to another level, but it is fitting that the original survives—at a level just as fine and fun as it was when Gad Norton opened the gates.

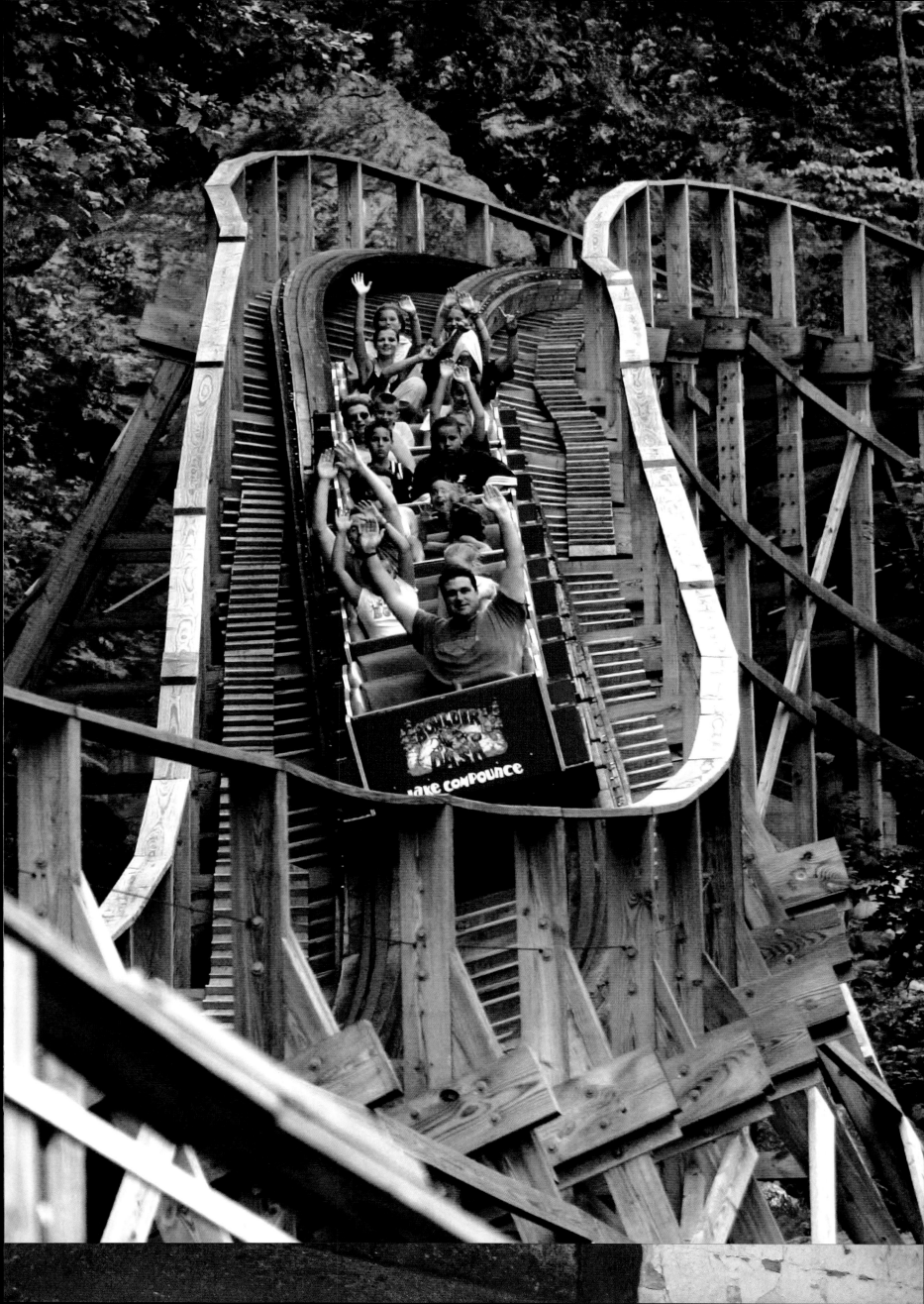

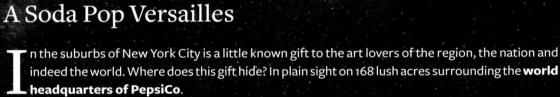

A Soda Pop Versailles

In the suburbs of New York City is a little known gift to the art lovers of the region, the nation and indeed the world. Where does this gift hide? In plain sight on 168 lush acres surrounding the **world headquarters of PepsiCo**.

It's true. Although the elegant seven-building complex in Purchase, designed by Edward Durrell Stone, may not be as prominent on the life-list of aesthetes as Louis XIV's little château in the burbs of Paris, the idea of elevating the site with outdoor gardens of fine statuary is of a piece. When Pepsi moved from Manhattan to Purchase in 1970, the company's CEO, Donald M. Kendall, for whom the sculpture gardens are named, wanted to create a museum without walls for his employees and for the general public as well. He selected the artworks himself, and they include efforts by masters: Auguste Rodin, Henry Moore, Alexander Calder (who personally sited his "Hats Off" in one of the gardens), Alberto Giacometti, Jean Dubuffet, Claes Oldenburg, Arnaldo Pomodoro (whose "Triad" is seen here). As that roster implies, the focus was on 20th-century artists. There are 45 sculptures in all, situated in a land-scape drawn by E.D. Stone Jr., son of the architect, who brought in perhaps 6,000 trees of 38 species and thousands upon thousands of flowers. The sum total is one of the finest sculpture gardens in the country, and it's free of charge to all.

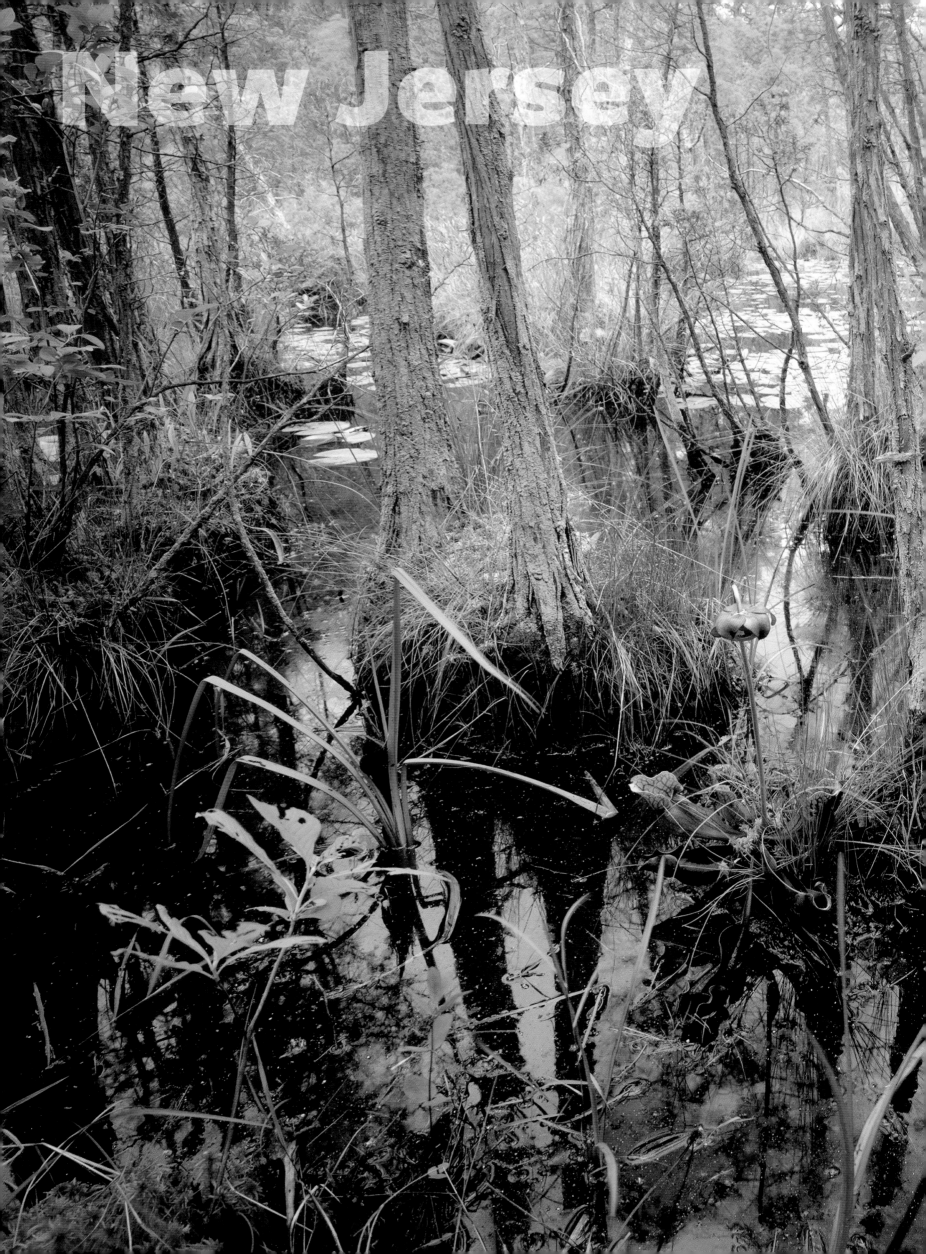

Devil of a Place

The **Pine Barrens** is a realm that exists somewhere between mythology—*The Sopranos* and *The X-Files* have found it accommodating, as did the legendary monster the Jersey Devil—and reality. What is this place, exactly? It is the largest parcel of open space between Massachusetts and Virginia, a coastal plain of more than a million acres covered largely by dense forest. There are hamlets within, a 49.5-mile hiking trail that goes right through and mountains with scenic vistas. The masterly John McPhee wrote a book about the Pine Barrens, and anything you need to know about the natural infrastructure of this region is in there, eloquently told.

Wetlands of all sorts are paradise for birders or canoeists. The flora in the Pine Barrens is interesting too: pygmy pitch pines, carnivorous plants, orchids, blueberries—the country's first cultivated blueberries were harvested here in 1916, and blueberry farms proliferate today. In the bogs, you'll find cranberries; New Jersey ranks third in cranberry production among all the states, thanks to the Pine Barrens. (You'll learn which state comes first later in this book. You'll likely be surprised.)

This region has, as mentioned, distinctions both esteemed and odd. In 1978 it became our nation's first national preserve; in 1938 humans battled aliens here in Orson Welles's sensational radio broadcast of *The War of the Worlds*; in 2001 it was the place where Tony Soprano's mobsters got lost while chasing a Russian gangster.

And of course there is the winged Jersey Devil, with its horse's head, dragon's body and bat's wings. See it, and you're doomed to misfortune. (Well, see it and you've already been pretty unfortunate.) You'd do better to come upon the spectral White Stag of the Barrens, which once showed its benevolent spirit by redirecting a run-amok stagecoach, thus preventing it from plunging into the river.

There's much more going on in the Pine Barrens than anyone might suspect.

Declaring Independence

In southeastern Pennsylvania are buildings, and crannies within buildings, that speak of the African American experience in our country—even as they seem to speak not at all.

Hopewell Furnace in Berks County is today pretty much a ghost town (below)—a historic site with 14 restored buildings, including a blast furnace, an ironmaster's house and several more dwellings where laborers lived. Hopewell was founded in 1771 by Mark Bird, for whom the town of Birdsboro was named. During the Civil War, when product from the Furnace was in great demand, business boomed.

In 1776, five years after Bird got his site up and running, the Reverend Alexander Dobbin built a home not far from Hopewell, in Gettysburg. The Dobbin House Tavern thrives there today at 89 Steinwehr Avenue—but that is not of significance here.

Mark Bird was a slave owner, as were many ironmasters of the time; in fact, with 18 slaves working at the Furnace, he was the largest slave owner in Berks County. When Pennsylvania sentiment and law turned toward abolition, many African Americans already working at Hopewell Furnace simply became legal employees.

With war approaching, abolitionists vociferously urged southern slaves to board something called the Underground Railroad. Tradition holds that the system for sneaking slaves north ran from roughly 1830 to 1865. In truth, people had regularly been escaping bondage for two centuries prior. But during the mid-1800s, efforts to grease the skids certainly grew in sophistication. In Gettysburg, the Reverend Dobbin opened one of the southernmost way stations on the Railroad in a secret room off the stairwell (opposite).

Not too far away, the already free blacks of Hopewell welcomed their brethren from the South, who were fleeing over the hills in increasing numbers. In 1856 the now considerable black population in the area established an African Methodist Episcopal Church and the first known African American cemetery in Berks County.

The cemetery still exists, as does **Dobbin's secret room**, as do the buildings of the Furnace—all of them harboring secret memories of a secretive time.

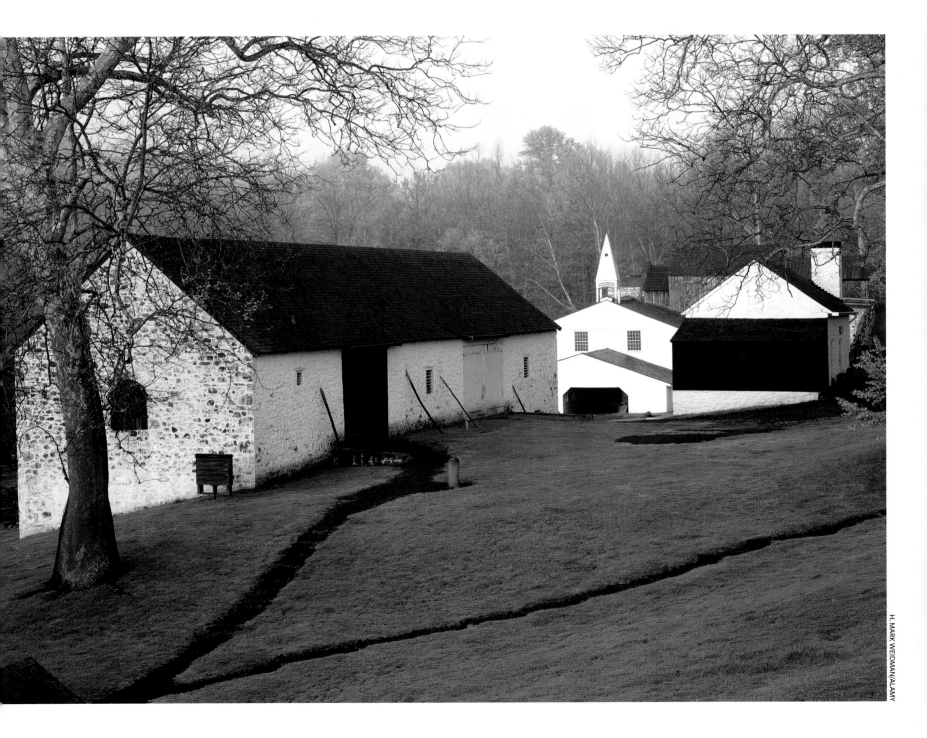

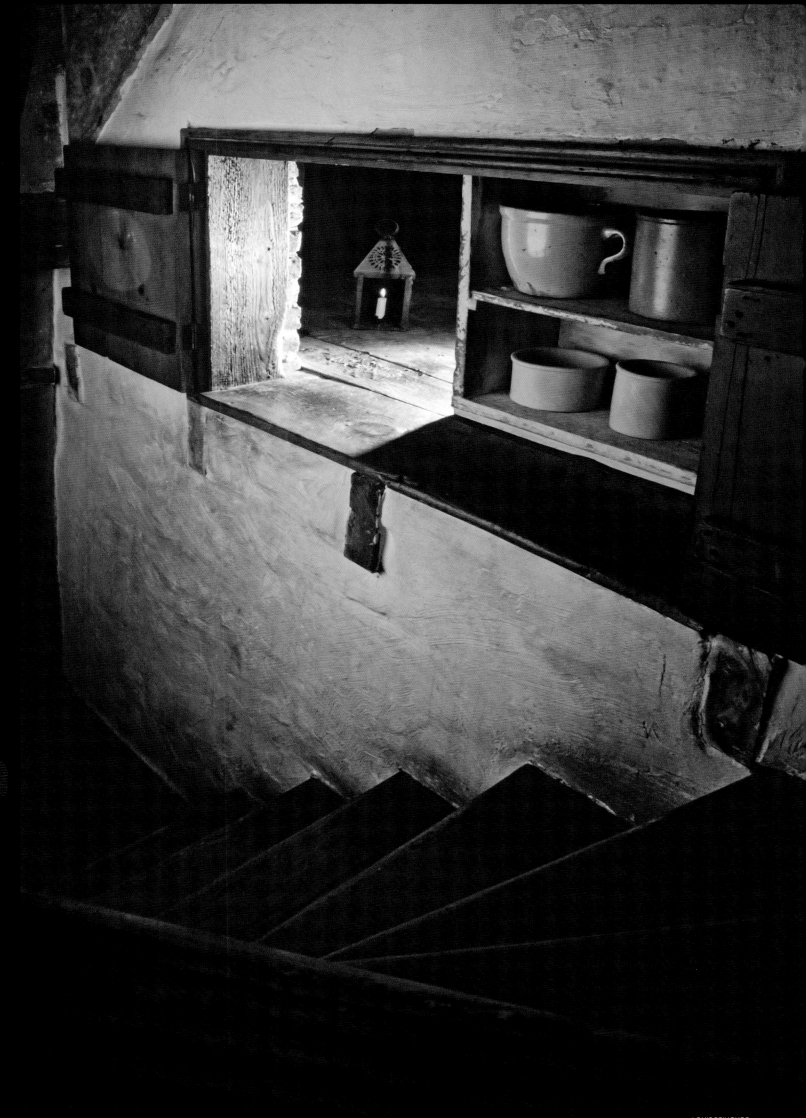

LOUIS PSIHOYOS

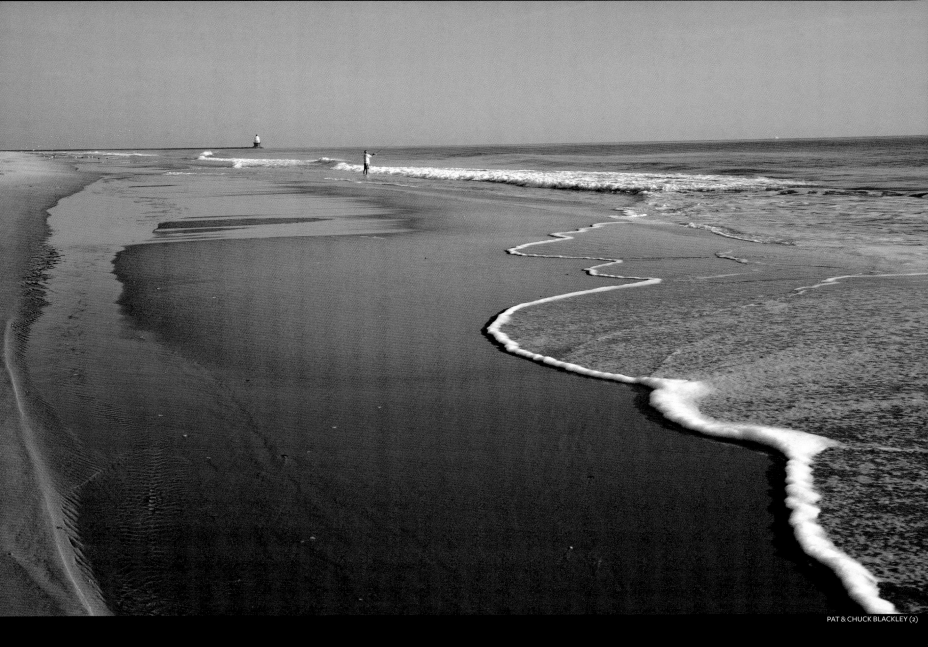

Dutch Treat

Among the second wave of European settlements in the New World—barely a generation behind the pioneering colonies at Jamestown in Virginia and Plymouth in Massachusetts—was a Dutch whaling outpost on the coast of what is now the state of Delaware. Situated at a point where Delaware Bay and the Atlantic Ocean meet at Cape Henlopen, this town of Swanendael, which mellifluously translates as "Valley of the Swans," was founded on June 3, 1631. It suffered an early history much harsher than its name within its first year when the local Lenni Lenape nation destroyed the settlement. But Swanendael was quickly reestablished, and it thrived as a principal Chesapeake Bay trading port for many decades.

Today the town is called **Lewes**, and although it is less well known than the nearby resorts Rehoboth Beach and Dewey Beach, it is a splendid place indeed—rich in history, rich in lore (pirates!), rich in scenic seaside beauty (opposite). The adjacent Cape Henlopen State Park features wonderful hiking trails and beaches for swimming (above), as well as the preserved Fort Miles, which was built in 1941 to protect Chesapeake Bay against enemy activity in World War II. (Lewes knew from rough history about the need for fortifications: The Cannonball House Marine Museum at the corner of Front and Bank streets is so called because the building took a direct hit during a British bombardment in the War of 1812.)

Lewes is worth noting in any travel book for its everyday charms, but is particularly worth visiting in a book on hidden America for its claim of being "the first town in the first state." Yes, it's the truth, it's certifiable: Swanendael was the first settlement founded in Delaware, and Delaware was the first of the colonies to ratify the U.S. Constitution. American town life began here.

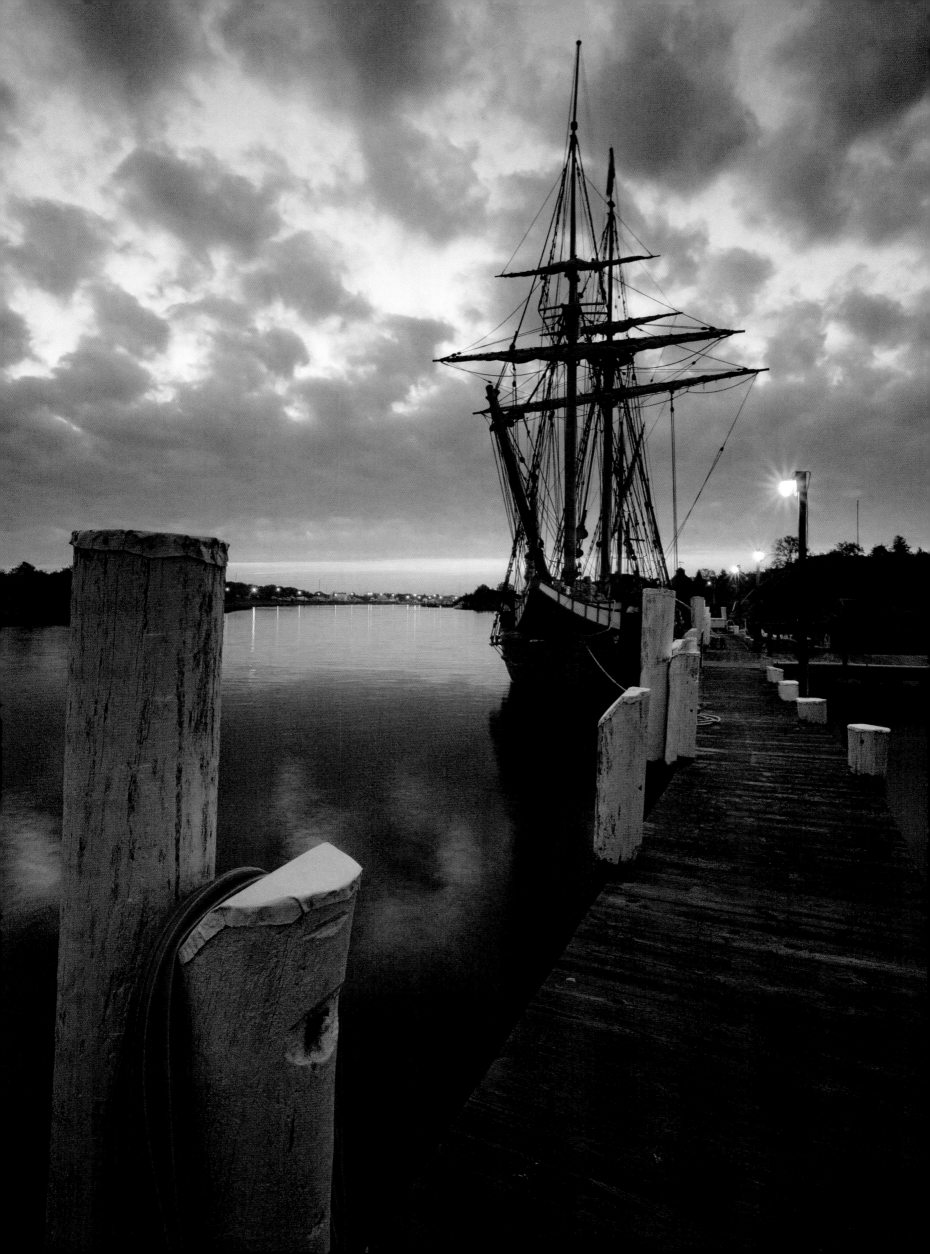

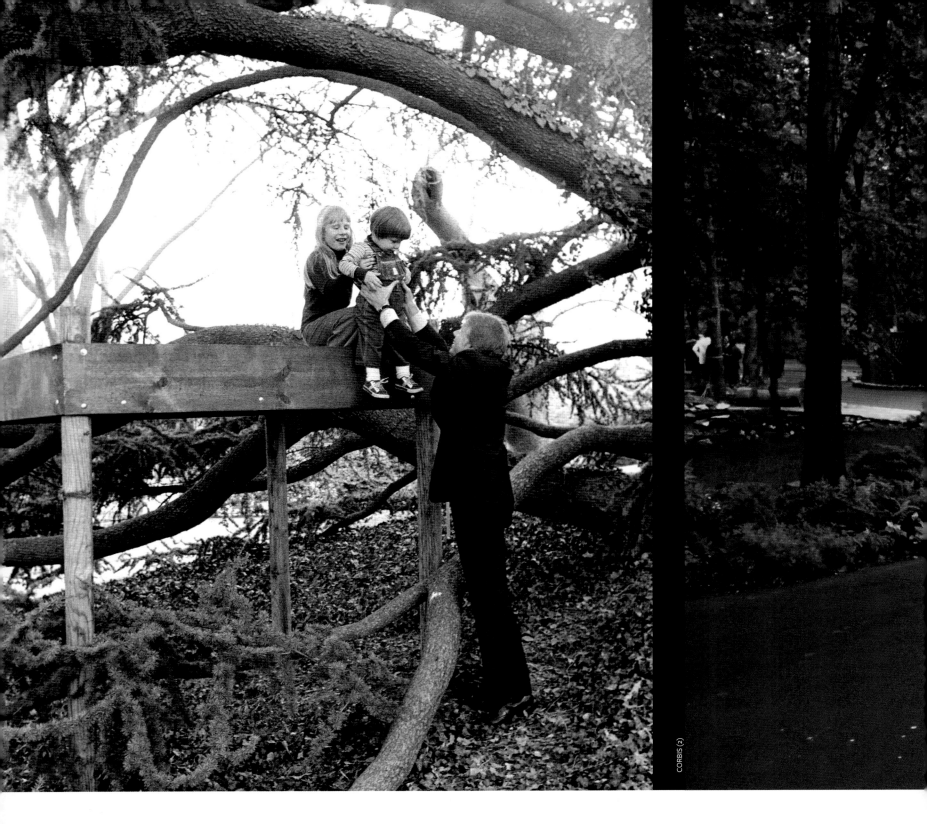

Presidential Privilege

Most all of the places in our book can be visited by you, the reader. *Most* of them. But we thought you would enjoy a voyeuristic peek at a few venues that are likely beyond your real-world purview. We won't be taking our golfers to the first tee at New Jersey's super-private Pine Valley, or our snorkelers to Ted Turner's private St. Phyllis Island off the coast of South Carolina. But we thought any American might be interested by what is behind the phrase "The President spent the weekend at **Camp David**."

Located about 60 miles north of Washington, D.C., in Maryland's Catoctin Mountain Park, this 143-acre retreat was begun as a WPA project in 1935 and has served as the Chief Executive's country home since 1942. It was called Shangri-La during the Roosevelt and Truman administrations, then was rechristened Camp David by President Eisenhower in honor of his grandson, Dwight David Eisenhower II. That moniker, it is interesting to note, is not its formal name. The compound is actually the Naval Support Facility

Thurmont, nodding to its status as a United States naval installation. Navy Seabees are charged with maintenance of the grounds, and an elite Marine Corps unit handles security—which, as you might imagine, is pretty tight.

There have been many small and grand moments at Camp David, from happy horseback-riding jaunts by the Kennedys in the early 1960s to the Jimmy Carter–brokered peace accord between Israel's Menachem Begin and Egypt's Anwar Sadat in 1978 to the marriage of George H.W. Bush's daughter, Doro, to Bobby Koch in 1992. (Above is Carter with daughter Amy and grandson Jason James at Amy's Camp David treehouse, circa '78.) Gerald Ford rode snowmobiles around the grounds, and Ronald Reagan enjoyed the woodworking shop.

In these quiet woods, walking from the main lodge to any of several cabins on the mulch-covered pathways, the Presidents are at their most human. We, the people, rarely get to see them that way. That may seem too bad, but then: Everyone deserves a little privacy.

Martyred for a Cause

In the 1850s, most antislavery northerners were urging that opposition to the proslavery South be pressed peacefully, but Connecticut native John Brown had no use for such pacifist philosophy. He wanted a violent response to southern aggression on this issue, and his deeds backed up his fiery words. In 1856 he went to Kansas Territory, where proslavery forces were engaging in terrorist acts. Brown organized a band of militants determined to "fight fire with fire." On the night of May 24, five proslavery settlers were taken from their homes on Pottawatomie Creek and hacked to death. Brown would later say that he wasn't part of the raiding party but approved of its actions.

As notorious as the Pottawatomie Massacre remains in the annals of pre–Civil War agitation, it does not rank as Brown's principal claim to fame. That would be his foiled attempt to incite a slave rebellion with a raid on the U.S. arsenal at **Harpers Ferry**, Virginia (right, in what is now West Virginia).

As far back as 1847, Brown had told the ex-slave turned abolitionist Frederick Douglass that he was committed to freeing slaves by force. A dozen years later, Brown's resolve was intact, and he set in motion a plan. On October 16, 1859, he led 21 armed men in an attack on the Harpers Ferry Armory, which contained 100,000 muskets and rifles. His aim, as his supporters (including Douglass) testified at Brown's subsequent trial, was to seize the firearms and distribute them to slaves in Virginia, then to push further south adding liberated slaves to his rebel army.

Brown did take the armory, but word of the raid reached Washington, and before long a Marine unit under the command of Robert E. Lee had "John Brown's Fort" under siege. (The instantly famous fortification is seen below, a few years afer the raid.) Brown was captured, and on December 2 was hanged in Charles Town.

Abraham Lincoln downplayed Brown—"a misguided fanatic"—but others lionized him. Ralph Waldo Emerson said Brown's martyrdom would "make the gallows as glorious as the cross." For many southerners, the raid was proof of a northern plot to use force to wipe out slavery. The Civil War was beckoning.

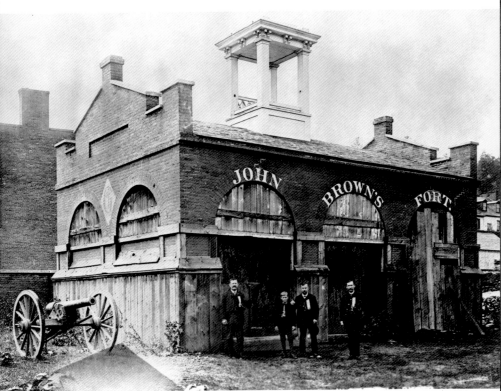

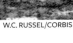

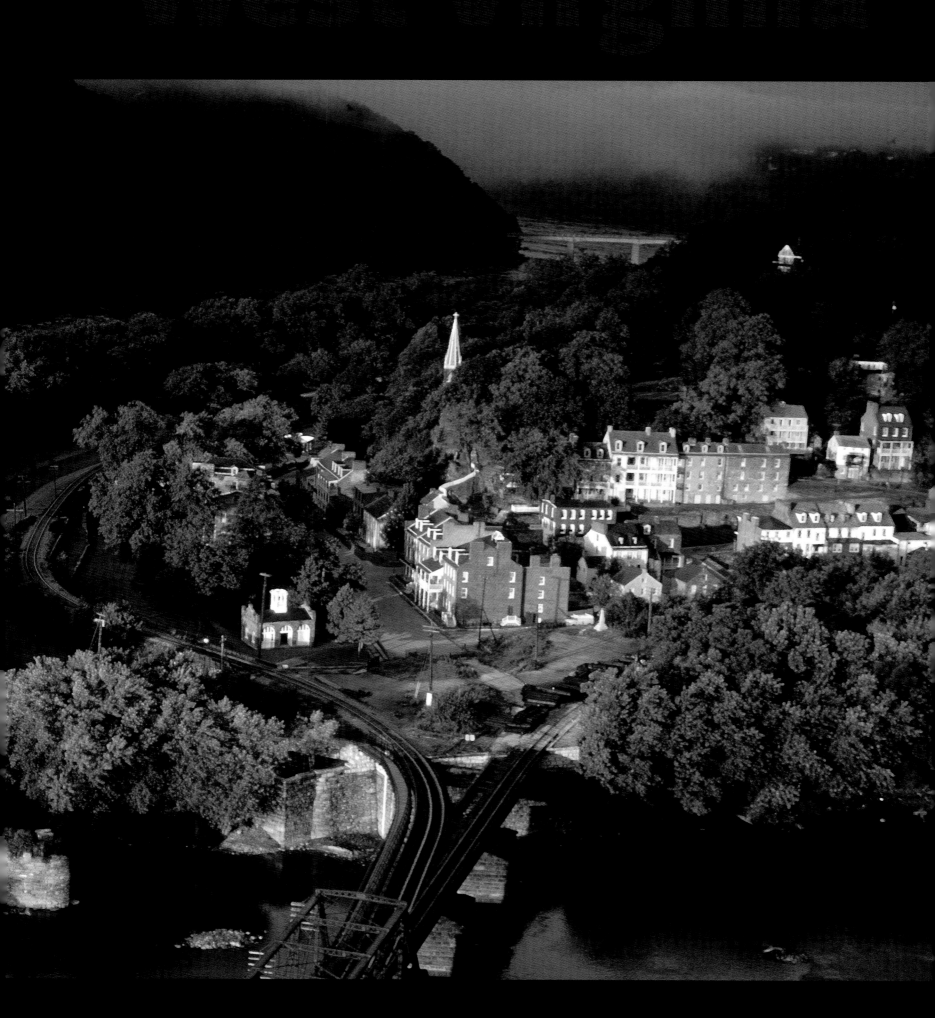

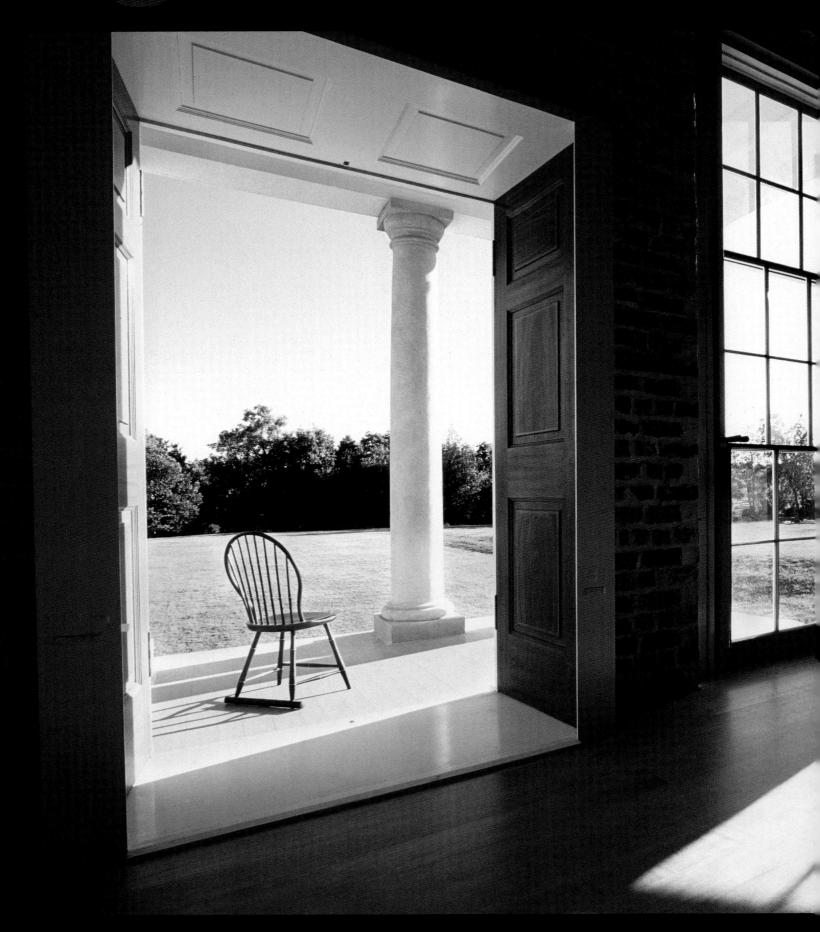

Virginia

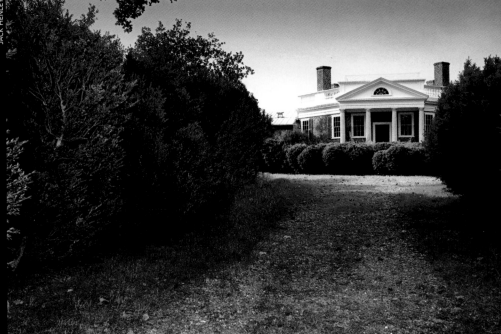

Thomas Jefferson Slept Here

In fact, he slept here often—and it is not Monticello. **Poplar Forest**, as the 4,800-acre plantation and its handsome house were both known, was built specifically as a refuge from the many visitors and daily bustle of life at his family home of Monticello.

Jefferson was, of course, his own architect. From his earliest studies of design, Jefferson had been fascinated by octagonal structures and had sketched many of them. Poplar Forest was the only one to be constructed.

The great man was still President when he oversaw the laying of the foundation in 1806. He was looking toward retirement, and was consumed with the idea of creating a country villa. The designs of 16th-century Italian architect Andrea Palladio influenced Jefferson's approach to his brick house, as did architectural touches he had observed in France, including floor-to-ceiling windows (left) and a 16-foot skylight that would allow the house's interior to glow.

Monticello, the University of Virginia and the Virginia State Capitol (not to mention the Declaration of Independence) are usually cited as Jefferson's masterworks, but the man himself considered Poplar Forest a triumph even before it was completed. "When finished," he wrote in 1812, "it will be the best dwelling house in the state, except that of Monticello; perhaps preferable to that, as more proportioned to the faculties of a private citizen."

It satisfied not only his aesthetic sense but also his desire for solitude. "I write to you from a place 90 miles from Monticello, near New London of this state, which I visit three or four times a year, & stay from a fortnight to a month at a time," Jefferson wrote to a correspondent. "I have fixed myself comfortably, keep some books here, bring others occasionally, am in the solitude of a hermit, and quite at leisure to attend to my absent friends."

In his day, this was Jefferson's secret retreat.

In our day, it still is.

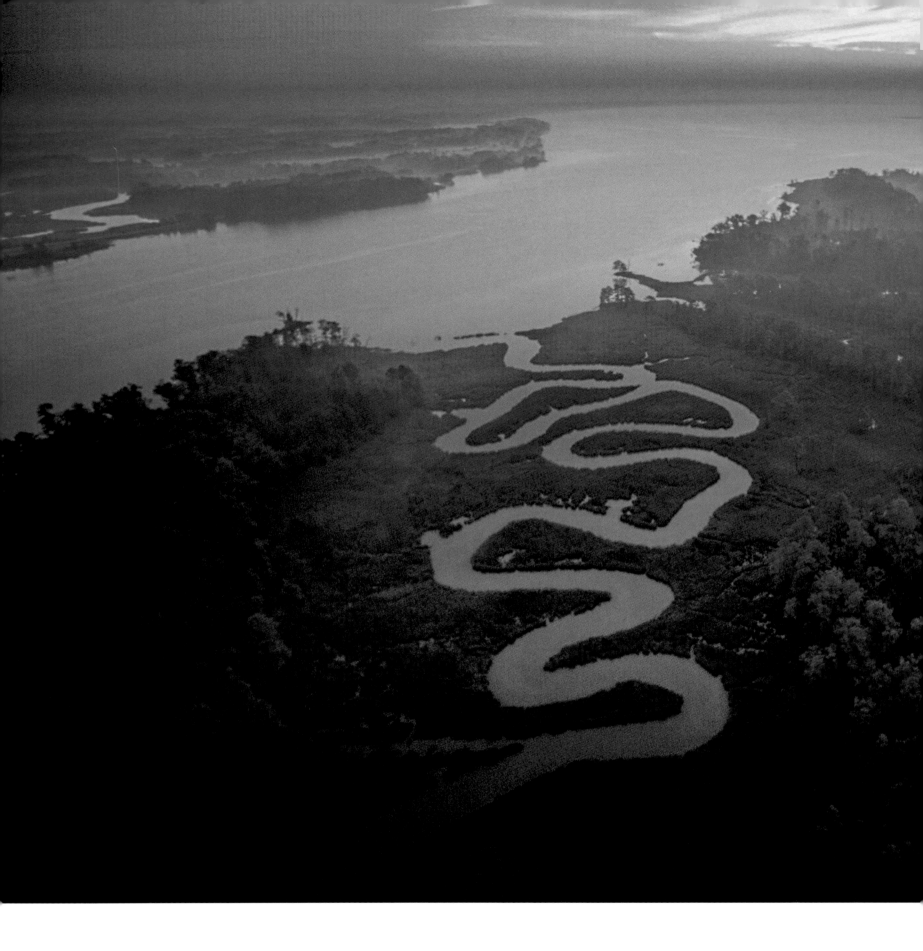

A Harsh New World

Even in the prelude to nationhood, America was a melting pot, as the Spanish were followed in their efforts at colonization by the British, French and Dutch, opening the way for waves of Irish, German, Finnish and Swedish immigrants. Many came in search of wealth, others for individual or religious freedom. Their aspirations informed what became known as "the American character."

Danger and the prospect of premature death were constant for the earliest settlers from Europe. Sir Walter Raleigh's 1585 attempt to establish a British settlement on Roanoke Island, off the coast of what is now North Carolina, failed, with the colonists returning to England the next year. Raleigh tried again in 1587, sending 91 men, 17 women and nine children. Their fate remains one of America's eeriest mysteries. When an English ship next visited Roanoke in August 1590, the sailors found no trace of the colony, only the letters CRO carved into one tree, the word CROATOAN into another. The colonists' intentions had been to travel north to the Chesapeake Bay and establish a community. Perhaps they did so, and ran afoul of the Indians there. Or perhaps they were taken in by the friendly Croatoan Indians to the south (still today, the Lumbee Indians of southeastern North Carolina maintain that they have Lost Colonists in their family tree). The truth remains unknown, and probably ever will.

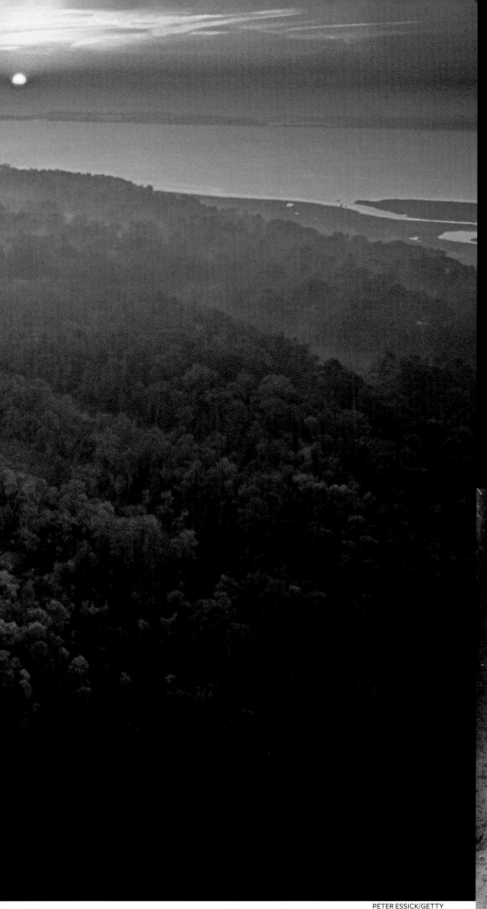

PETER ESSICK/GETTY

Another group of Englishmen settled near the Chesapeake Bay in 1607, naming their community after the reigning British king, James I. The 105 adventurous men had seen "faire meddowes and goodly tall Trees" along the coast; would that they had stopped at one of those sites. "**James Towne**," where they did put down roots, was swampy and its drinking water impure. For years the colonists endured dysentery, hunger, fires and hostile natives—but endure they did, and today Jamestown retains its distinction as the first permanent English settlement in America. (Above is a view of Jamestown Island, while at right is a 400-year-old skeleton, approximate to the time of the original settlement, found at an excavation site there.)

IRA BLOCK/GETTY

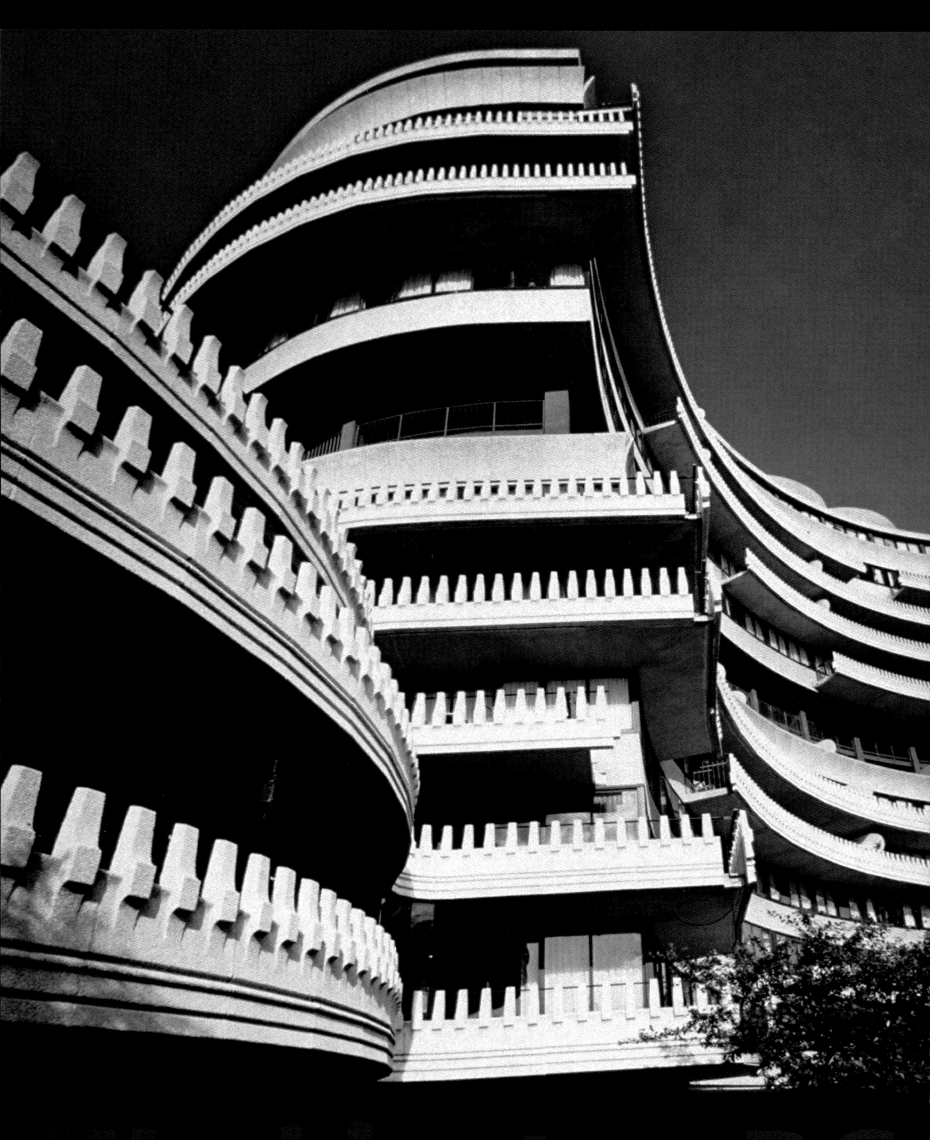

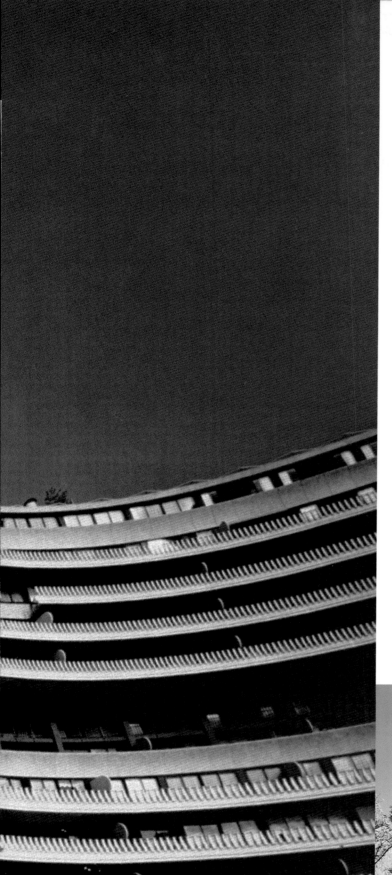

Halls of Infamy . . . and Nobility

In the fabulously named Foggy Bottom neighborhood of Washington lies a superblock upon which sits the vast Watergate complex, a swirling, modernist group of edifices that includes a hotel and hundreds of offices and apartments (left). On the sixth floor of one of the two office buildings—the one with the Virginia Avenue address—something happened in May and June of 1972 that would, as events unfolded, forevermore render the name **Watergate** famous—or, rather, infamous.

On that floor at that time were the headquarters of the Democratic National Committee, which was engaged in an effort to unseat Republican President Richard M. Nixon in the coming election. On the night of May 28, several intruders—"the burglars"—broke into the offices of DNC chairman Larry O'Brien. They took some photographs and placed some wiretaps. These bugs would be monitored by Republican operatives holed up across Virginia Avenue at a Howard Johnson's Motor Lodge (which, incidentally, is now a dormitory for grad students at George Washington University). Five burglars returned a few weeks later, on June 17, to replace a malfunctioning wiretap, and they were caught. As any student of American political history knows, the arrest led to a cover-up, which led to a journalistic and then a legal investigation, which led to the "Watergate scandal" and the disgrace and resignation of President Nixon.

Up on **Cedar Hill**, overlooking such squalid doings from a lofty, airy perch, is a fine, handsome, but otherwise unpretentious home (below) that was, in fact, the final house lived in by the heroic former slave Frederick Douglass. Here he spent his last 18 years playing the contented patriarch, as well as the living legend. After his death on February 20, 1895, his widow sought to ensure his place in history, and today part of it lives on in the house, tours of which can be arranged.

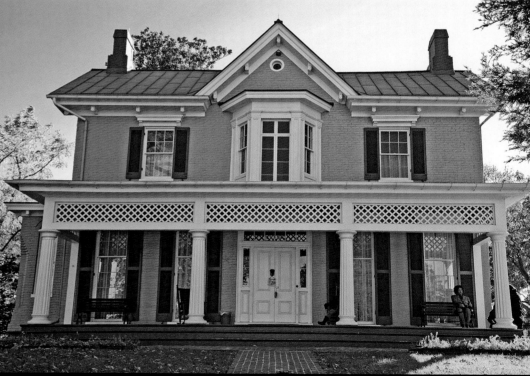

41

Mint Juleps Served Here, Too

Kentucky is thoroughbred country; everybody knows that. From pastoral Keeneland in Lexington to legendary Churchill Downs in Louisville and on the rolling grounds of a hundred horse farms in between, the air is rife with equine scent. In spring, those who play the horses among the refined, smart set don their big hats and place their big bets—joined, on Derby Day, by the masses.

Less famously and in fewer places, South Carolina is thoroughbred country too, with a pedigree just as true-blue as that of the Bluegrass State. In its southwestern section is **Aiken**, a small-to-medium-size antebellum city of handsome architecture and aristocratic bearing (opposite). The Willcox inn has hosted such as Franklin D. Roosevelt and Winston Churchill, and the horse tracks and farms in and around town have entertained a luxe clientele from all parts of the world since the late 1800s. In the spring and fall polo seasons, the action is fast and furious at Whitney Field and 26 other polo fields, and there is also a steeplechase in town and a nonbloody version of fox hunting just outside it.

They ride to the hounds in Middleton, over near Charleston on the coast, as well, where the Equestrian Center at the Inn at **Middleton Place** has about 50 foxhounds and 6,000 available acres upon which to disport. The grounds at Middleton Place (below) are fascinating to stroll as well as to hunt: This is a sumptuous 18th-century plantation that survived both the Revolutionary War and the Civil War intact and that today sings a resonant song of the South.

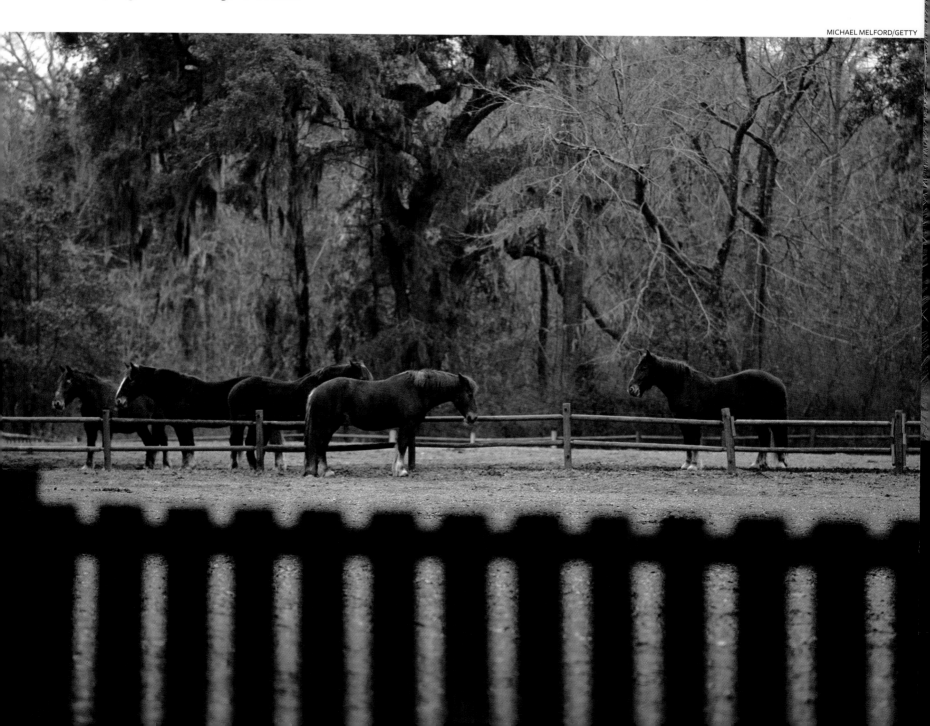

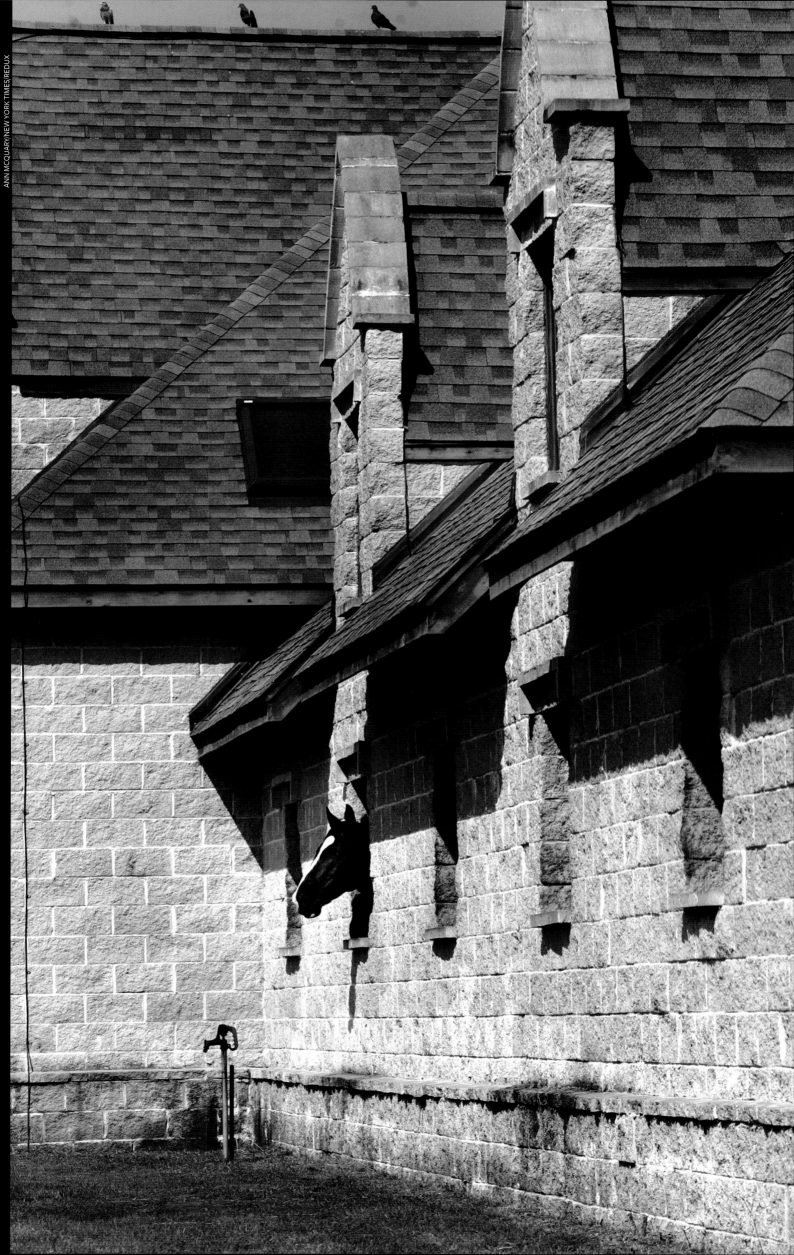

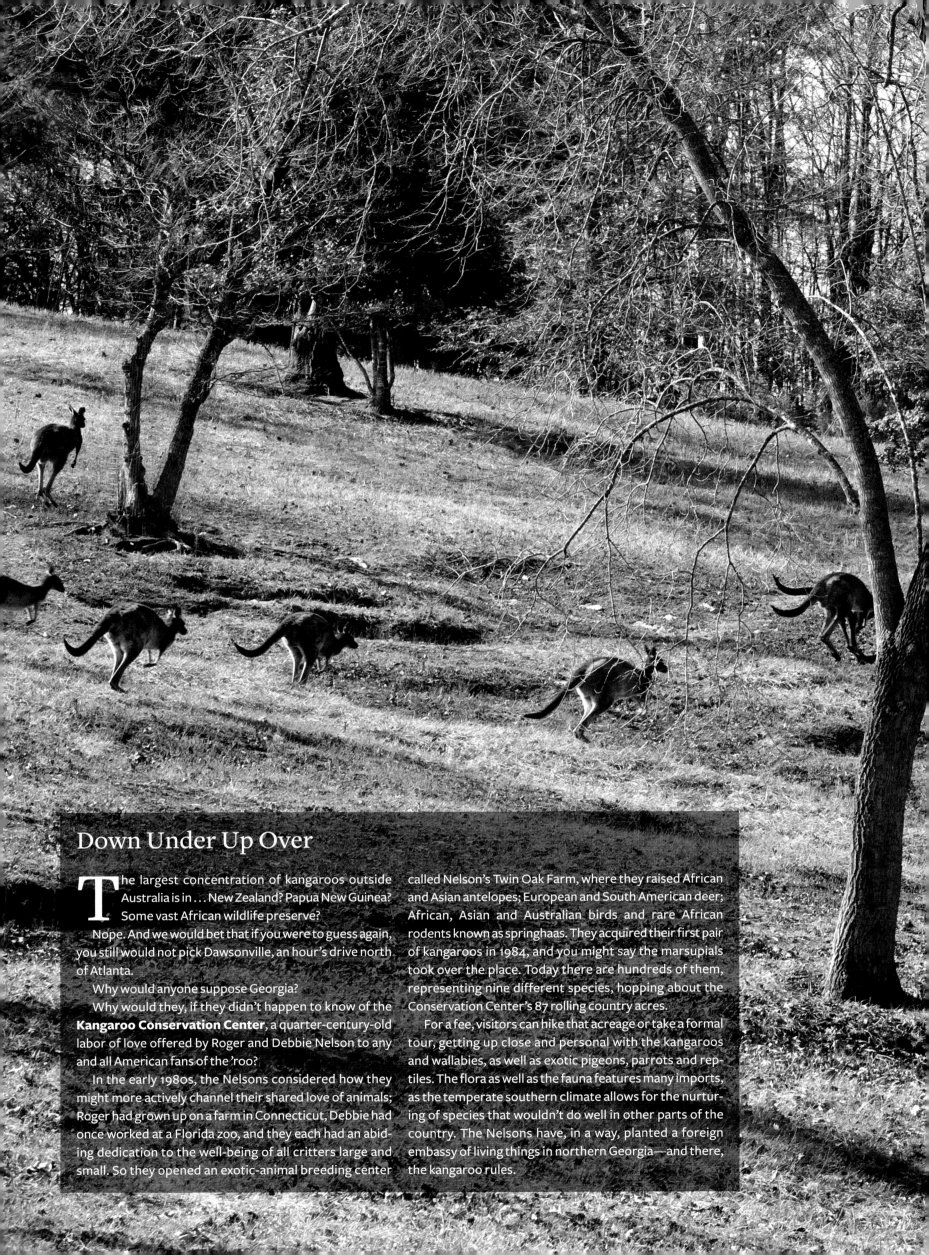

Down Under Up Over

The largest concentration of kangaroos outside Australia is in . . . New Zealand? Papua New Guinea? Some vast African wildlife preserve?

Nope. And we would bet that if you were to guess again, you still would not pick Dawsonville, an hour's drive north of Atlanta.

Why would anyone suppose Georgia?

Why would they, if they didn't happen to know of the **Kangaroo Conservation Center**, a quarter-century-old labor of love offered by Roger and Debbie Nelson to any and all American fans of the 'roo?

In the early 1980s, the Nelsons considered how they might more actively channel their shared love of animals; Roger had grown up on a farm in Connecticut, Debbie had once worked at a Florida zoo, and they each had an abiding dedication to the well-being of all critters large and small. So they opened an exotic-animal breeding center called Nelson's Twin Oak Farm, where they raised African and Asian antelopes; European and South American deer; African, Asian and Australian birds and rare African rodents known as springhaas. They acquired their first pair of kangaroos in 1984, and you might say the marsupials took over the place. Today there are hundreds of them, representing nine different species, hopping about the Conservation Center's 87 rolling country acres.

For a fee, visitors can hike that acreage or take a formal tour, getting up close and personal with the kangaroos and wallabies, as well as exotic pigeons, parrots and reptiles. The flora as well as the fauna features many imports, as the temperate southern climate allows for the nurturing of species that wouldn't do well in other parts of the country. The Nelsons have, in a way, planted a foreign embassy of living things in northern Georgia—and there, the kangaroo rules.

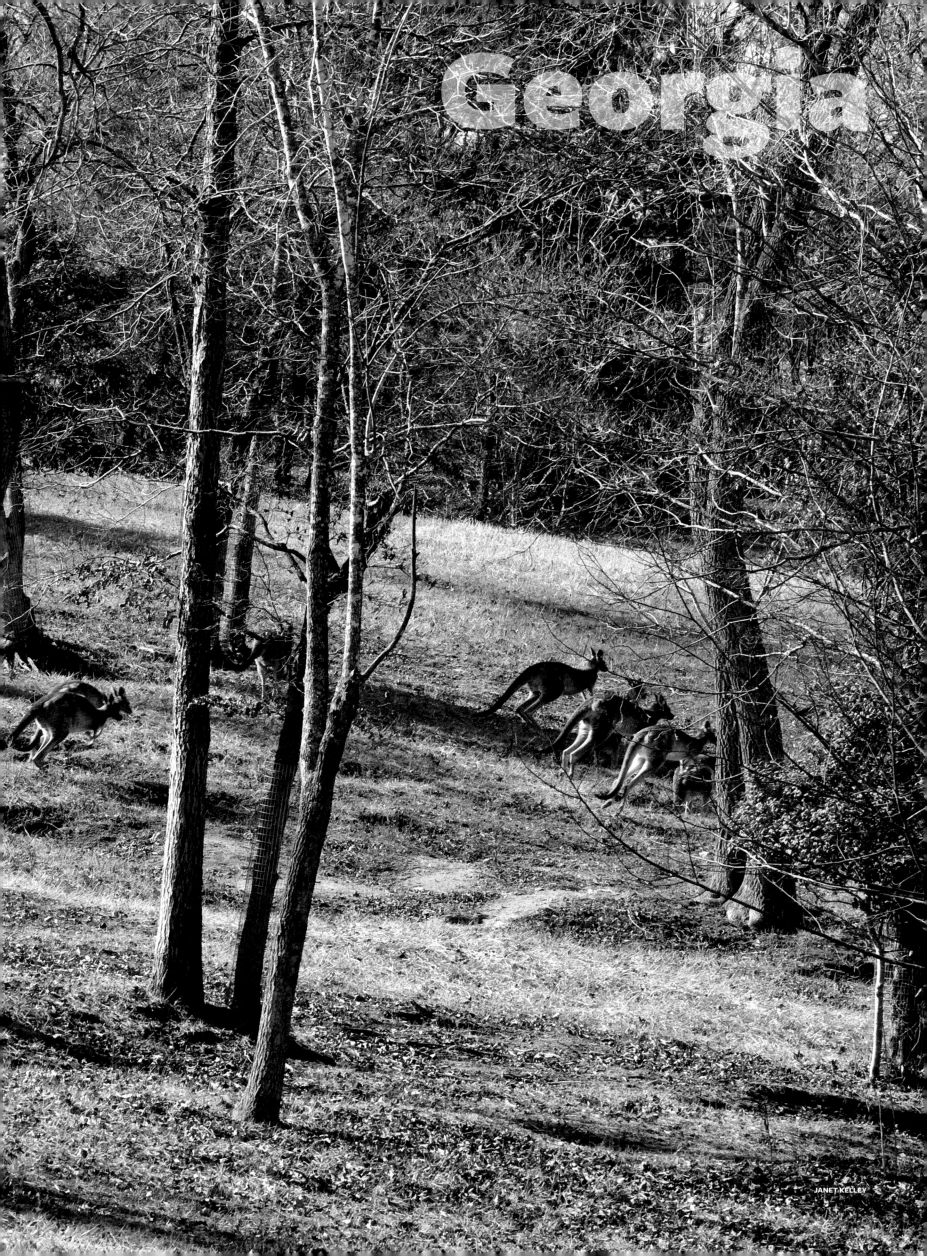

Georgia

Where Cultures Clashed

Several decades before the English landed at Jamestown Island in what would become the Virginia colony, both the French and Spanish had tried their hand at colonization in the Caribbean and, then, on the continental mainland.

Christopher Columbus, sailing upon an ocean blue, did not, of course, discover America in fourteen hundred and ninety-two; in fact, he never even stepped foot upon the place. Having set out for Japan and India, he delivered Cuba and Hispaniola—or, in the words of historian Daniel J. Boorstin, Columbus "promised a gold mine, and only found wilderness." A successor, Juan Ponce de León, pushed farther into that wilderness, landing in Florida in 1513. That same year, Vasco Núñez de Balboa reached the Pacific, and not long after, Hernando Cortés arrived in Mexico. What is now the United States was about to be invaded on all sides.

In West Florida, Tristán de Luna y Arellano founded the Pensacola colony in 1559, but the original settlement there lasted only two years due to famine and trouble with local natives. In 1564 the French tried to establish an outpost in what is today Jacksonville, but the Spanish wiped it out the following year.

Also in 1565, yet another Spanish explorer, Pedro Menéndez de Avilés, founded a settlement in northeastern Florida on the Atlantic coast and named it for **St. Augustine**. That thriving town—the ancient walls and an interior room are seen here—stands today as the oldest permanent white settlement in the country.

And what is it that we see in the picture on the opposite page, which was taken in one of the last unspoiled Atlantic coastal wetlands, one that lies within the 46,000-acre **Timucuan Ecological and Historic Preserve** in Jacksonville? We see an uprooted tree exposing a large gathering of shells. But this isn't simply a residue from tides long since departed; the shells tell a different tale. This is an oyster shell midden, the remains of feasts that may date back 1,000 years—a half a millennium before European ships hove into view offshore, complicating the natives' lives greatly.

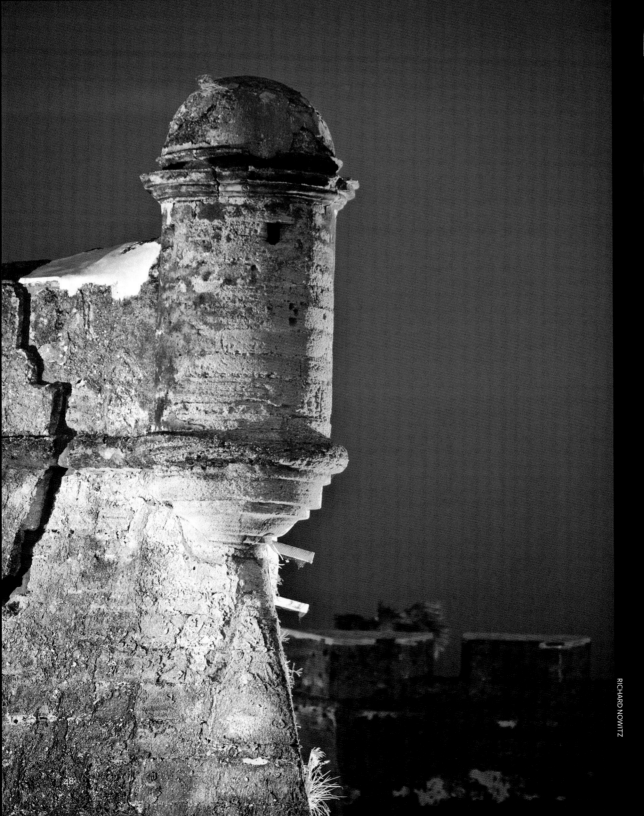

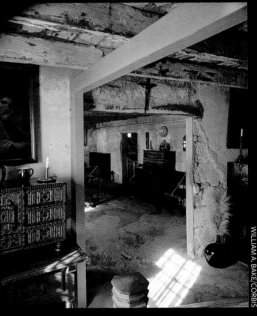

WILLIAM A. BAKE/CORBIS

RICHARD NOWITZ

NATHAN FARB

48

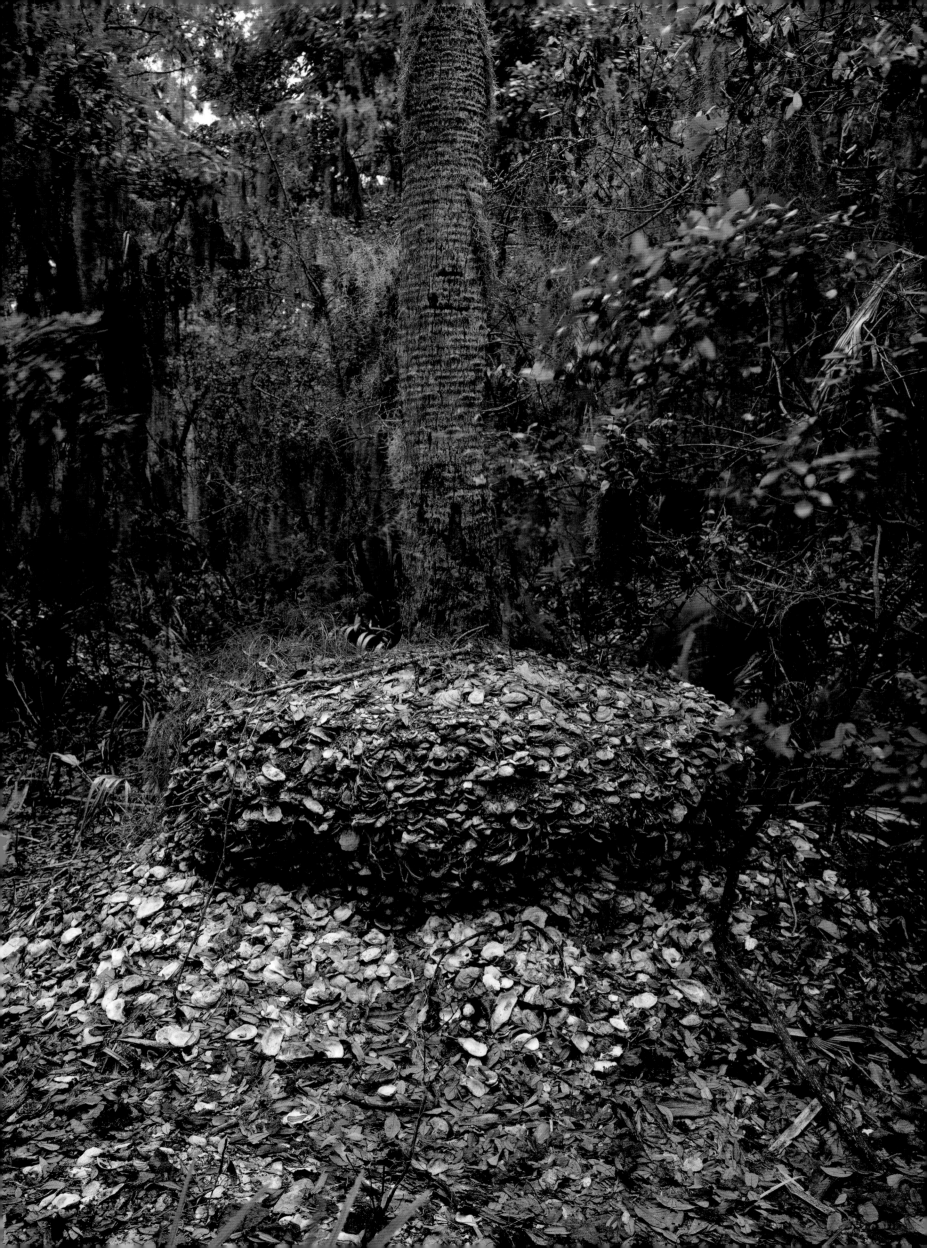

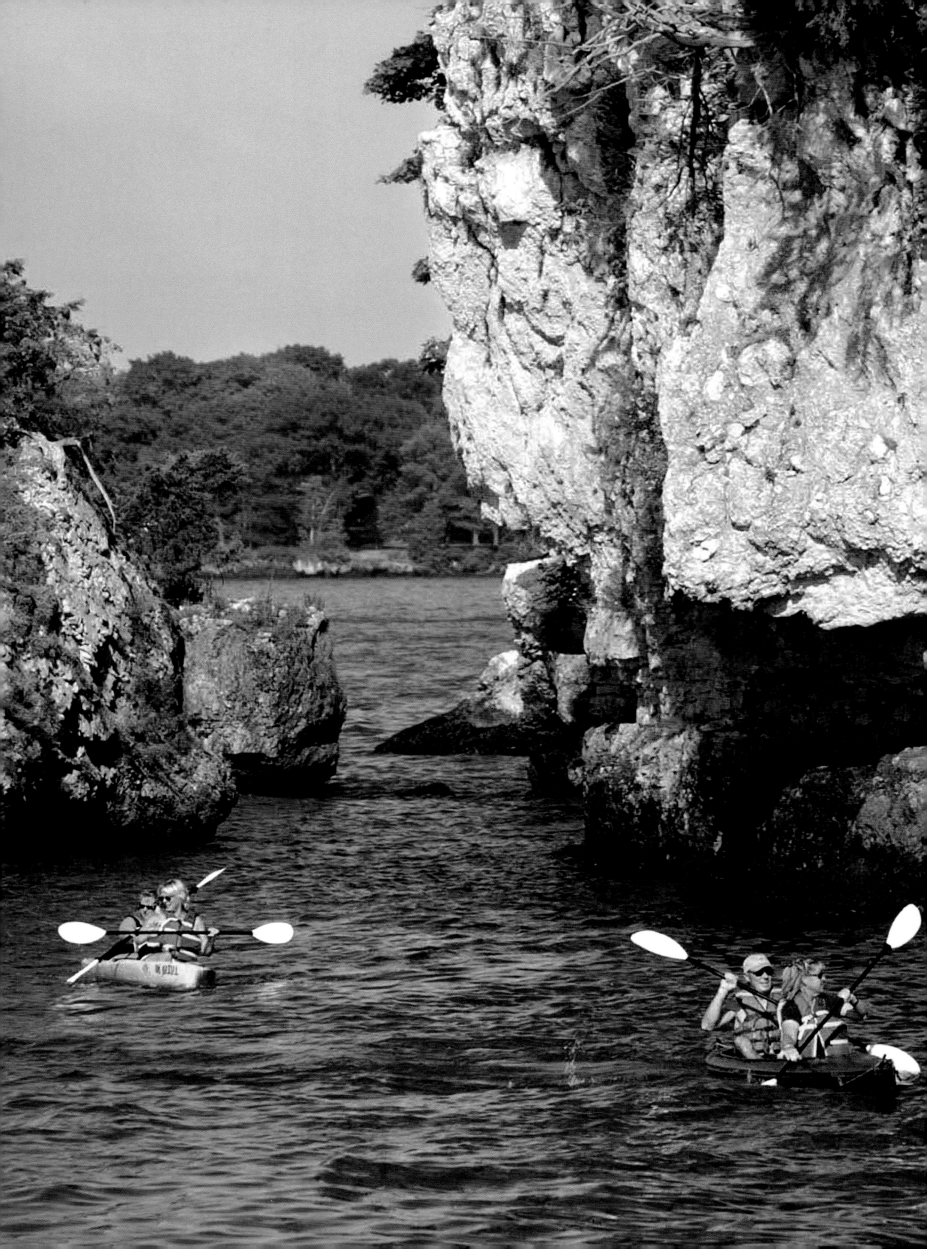

A Colorful Family

As a unit, they are known as the **Lake Erie Islands**. Besides the truly tiny ones such as Rattlesnake and Gibraltar, the principal four are Kelleys Island and then three named for an alluring fish: South Bass, Middle Bass and North Bass. They are all related by proximity, but are not what you would call close cousins.

South Bass, the nearest to the mainland ferry ports Catawba and Port Clinton, bristles with life in its harbor town, the whimsically named Put-in-Bay. The bars and family amusements are destinations of summer-season revelers, and for many, a choice experience of the islands is an elevator ride to the top of the 352-foot-high pink granite column that sprouts from the grounds just east of Put-in-Bay's harbor. This grandiose Doric curiosity is called Perry's Victory and International Peace Memorial; it commemorates a triumph over Britain's Lake Erie fleet by Commodore Oliver Hazard Perry during the War of 1812. The viewing platform on high does indeed afford South Bass visitors a splendid view of the neighboring isles.

But they should move in closer; there are hidden pleasures to enjoy beyond Put-in-Bay. Kelleys, the other island of some size, is also reachable by mainland ferry, but is hardly as bustling as South Bass. A ruined winery here evocatively tells of a past industry based upon the grapes that grow on all four major islands. In Kelleys Island State Park, large glacial grooves tell an older tale: of the fierce forming of these outcroppings during the last ice age.

Middle Bass Island had a long-standing winery too, which is also now kaput. For whatever reason, this was the island for U.S. Presidents: Five of them visited the place, including the soon-to-be-elected William Howard Taft in the summer of 1908 (below). From there, take a kayak (left) across the Erie waters to North Bass, the northernmost out (18 miles) and least developed island. There, enjoy walking trails amidst the grape vines growing wild.

With each leap away from the mainland, the Lake Erie Islands travel increasingly into the past—incrementally losing the trappings of our modern world.

In Search of Daniel Boone

Today, the road snakes through the Pine Mountain State Resort Park (opposite) and along the Cumberland Gap, and you can buzz along in your car, but in 1775 Daniel Boone and his confreres had to use axes to cut through this Appalachian wilderness. Boone, a native Pennsylvanian who grew up there and in North Carolina, moved to Kentucky as an adult for the land and opportunity it offered him and his family (he would father nine children).

This trailblazing colonist did indeed have adventures, and he began to acquire a reputation—particularly when he and his friends rescued Boone's daughter Jemima and two other teenage girls after they'd been kidnapped by an Indian war party in 1776. His became the name most associated with the white man's important push over **the Appalachians**, which theretofore had been seen as the colonies' western boundary. Legendary stories presented as fact in Boone "biographies" gained such currency, they would later inform the immensely popular fictions of James Fenimore Cooper's *Leatherstocking*

Tales. Boone himself demurred: "Many heroic actions and chivalrous adventures are related of me which exist only in the regions of fancy. With me the world has taken great liberties, and yet I have been but a common man."

Boone was able to escape his celebrity somewhat in 1799 when he moved with his family to Missouri, where he lived out the last of his many days, dying just before his 86th birthday, in 1820. He was buried next to his wife, Rebecca, in a family plot.

The real and surreal Boones can be parsed today in many mountain towns, villages and forests—in the Daniel Boone National Forest, and in Boone and Nicholas counties (in Nicholas there still stands a cabin, above, that Daniel himself built and lived in). Was he "but a common man" or, rather, as the TV-show theme song had it, the "rippin-est, roarin'est, fightin'est man the frontier ever knew!"?

Or was he something in between?

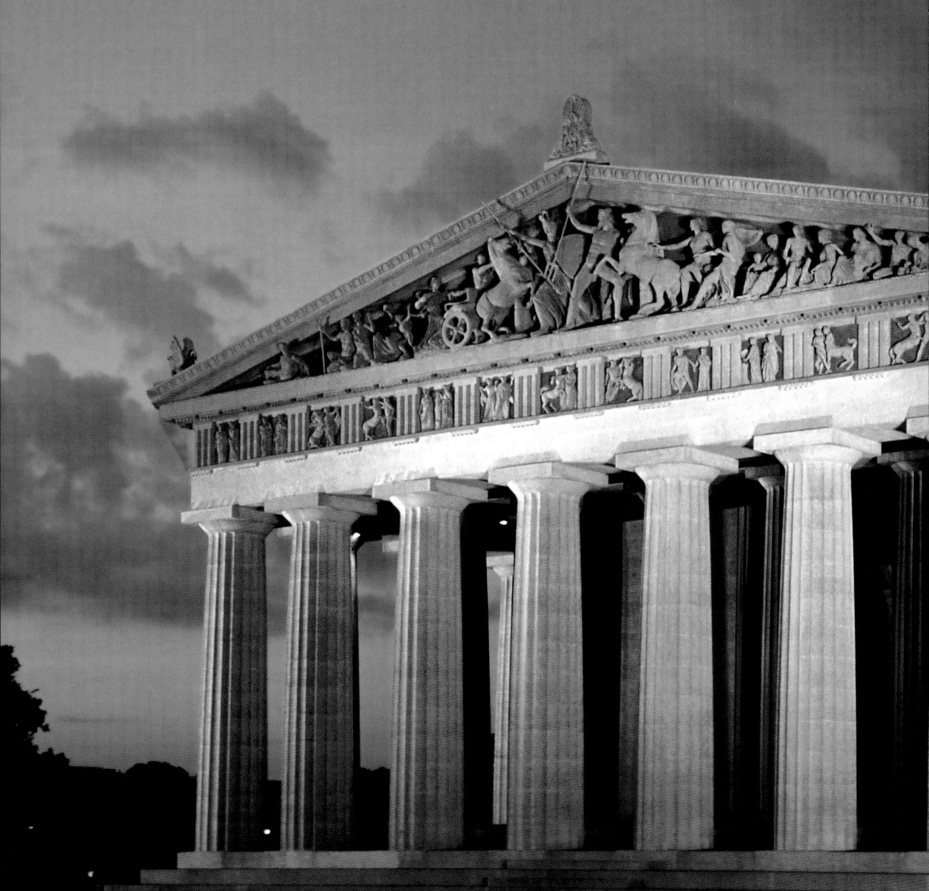

Tennessee

It's Greek to Us

Someone obviously took the notion of Nashville as the "Athens of the South" very seriously. Or at least seriously enough that it was decided a full-scale replica of **the Parthenon** would be a suitable, nonironic centerpiece for the 1897 Tennessee Centennial Exposition.

Back then, the Parthenon—U.S. version—was not alone but was one of a collection of edifices created in emulation of classic structures from around the world. These were precise to a degree. Rather than employing marble dating to 438 B.C., as is the case with the great building in Greece, the Tennessee craftsmen behind the modern-day Parthenon used plaster, wood and brick. In the days and years after the Exposition, the Parthenon's neighboring replicas were all torn down or taken elsewhere; the Knights of Pythias building, for instance, was moved to Franklin, Tennessee. But the Parthenon persevered, prospered and was, in fact, improved. By the 1920s it was regarded as a certifiable local landmark, as natural in its setting as a silo on the rural Tennessee horizon, and was wholly rebuilt in concrete, using the original foundations. Large doors to the cella, or interior chamber, made of bronze were installed. Details were polychromed in colors based on studies of what the original Greek building's flourishes, long since faded, looked like.

Decades later, in 1990, the Nashville Parthenon received a treasure fit for a Greek god when sculptor Alan LeQuire re-created the colossal, 42-foot-high Athena Parthenos statue that had provided a focal point on the Acropolis in Greece. Eight pounds of gold leaf bring Athena and her serpent to vivid life, and it is an immense irony that the Tennessee building and its accoutrements—being relatively new, based upon scholarly research and, well, unruined—are closer to what ancient Athenians actually saw on a day-to-day basis than are the famous Greek ruins.

Every year, thousands of unsuspecting visitors to Music City flock to Nashville in search of the Opry only to come across another grand ol' building in Centennial Park that makes them rub their eyes and wonder whether they've taken a massively wrong turn.

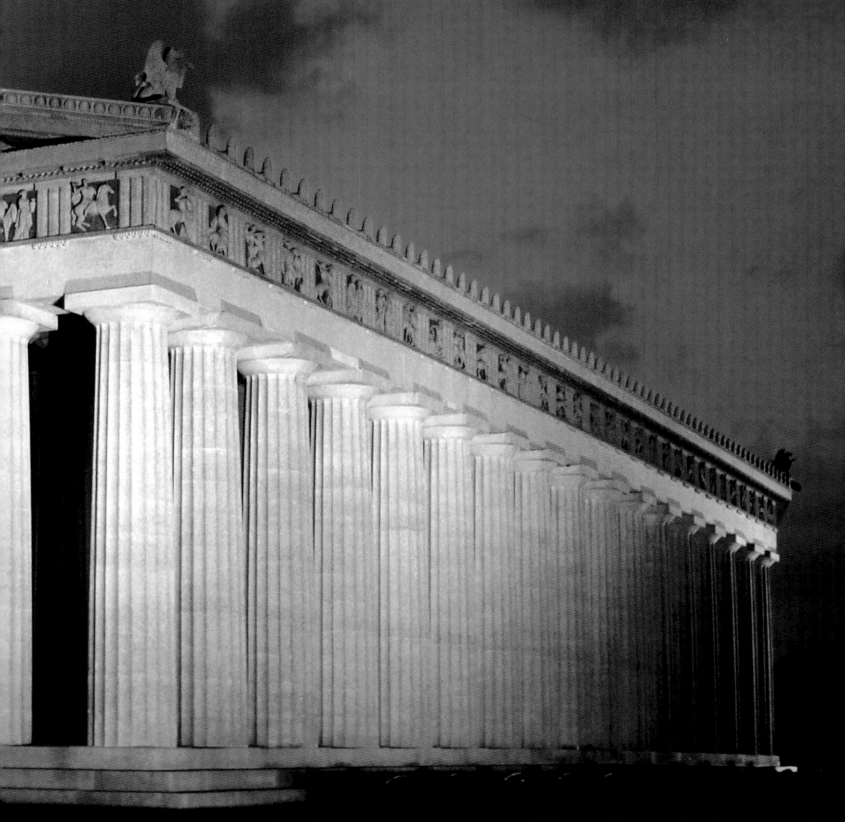

GARY LAYDA

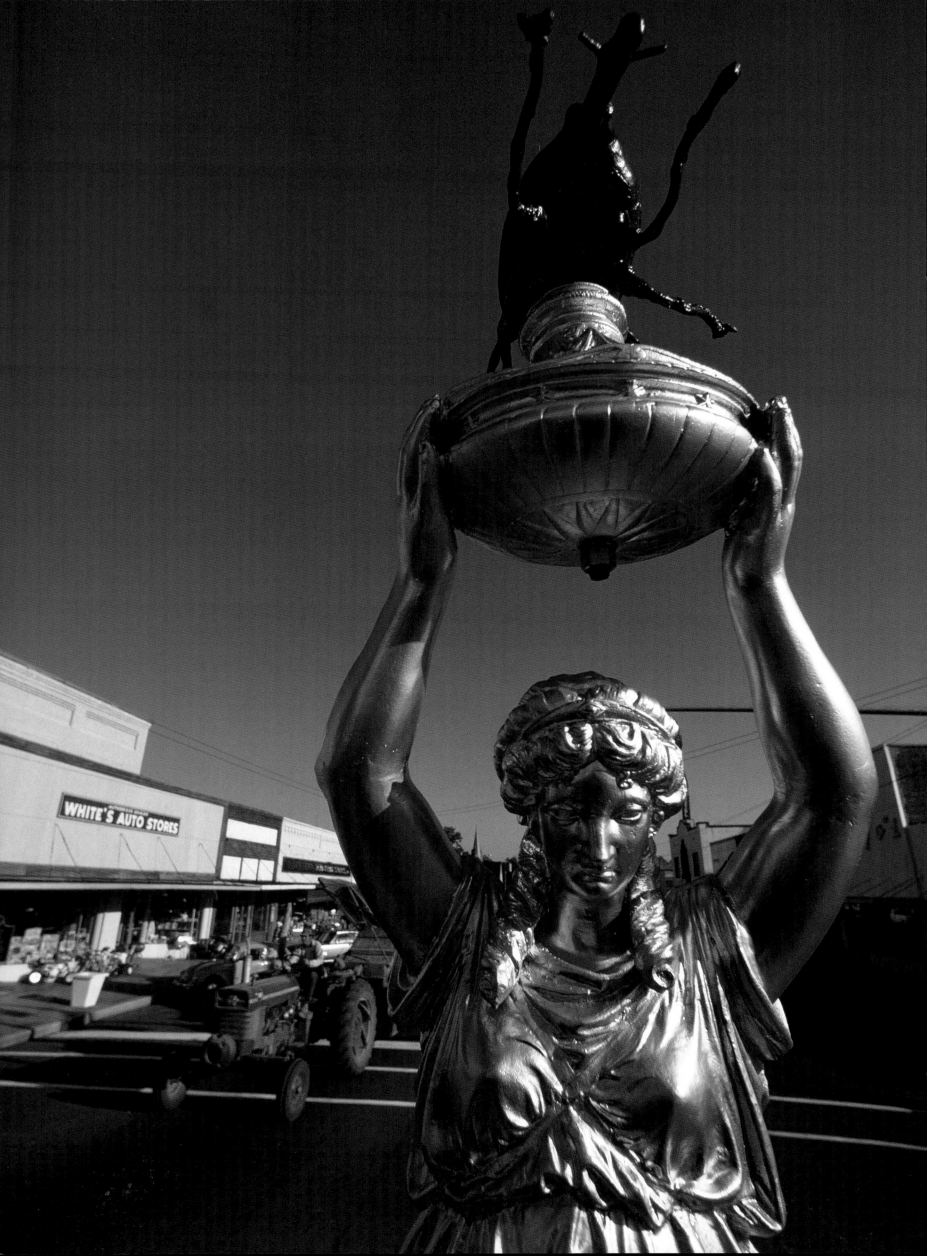

In Tribute to Things Great and Small

I n Alabama are two ornate creations that hearken to subject matter that is, on the one hand, grand beyond compare and, on the other, mundane in the extreme. A hillside on the campus of St. Bernard Abbey in Cullman is filled with 125 scale-model celebrations of the world's great churches, shrines and cathedrals (below). Meantime, in downtown Enterprise, at the corner of Main and College streets is a statue of a woman in a flowing gown (opposite) that wants to inspire contemplation of an agricultural pest. Both the **Ave Maria Grotto** and the **Boll Weevil Monument** were the fruits of a driven individual's inspiration and effort, and in that, they are a tribute to mankind's doggedness as much as to their stated foci.

Brother Joseph Zoettl, a native of Bavaria and a Benedictine monk at the Abbey, began in the early years of the 20th century a lifelong project of fashioning, out of whatever materials or junk was at hand, replicas of famous buildings and sites. Hunkered in his workshop, using postcards as references and getting many proportions wrong, he constructed fantastic representations of St. Peter's Basilica, the Tower of Babel, the Hanging Gardens of Babylon, the Monte Cassino Abbey—and more whimsical buildings like Hansel and Gretel's Temple of the Fairies. Then he placed these creations on the hillside, and a strange spiritual world grew into being.

In 1915, about the time Brother Joseph had embarked upon his 50-year mission of miniaturization, the boll weevil, indigenous to Mexico, first appeared in Alabama. Within years, the state's cotton crop was being decimated. Many farmers converted their acreage to peanuts and other plants. The diversified agricultural yield turned out to be a saving grace, and a local businessman in Enterprise, Bon Fleming, thought it right to salute the insect that had inadvertently spurred reform. Sculpted in Italy at a cost of $1,800 and erected in 1919, the oft-vandalized Boll Weevil Monument today stands protected in Enterprise's Depot Museum. The one at the corner of Main and College is, like Brother Joseph's magical buildings, a fine copy.

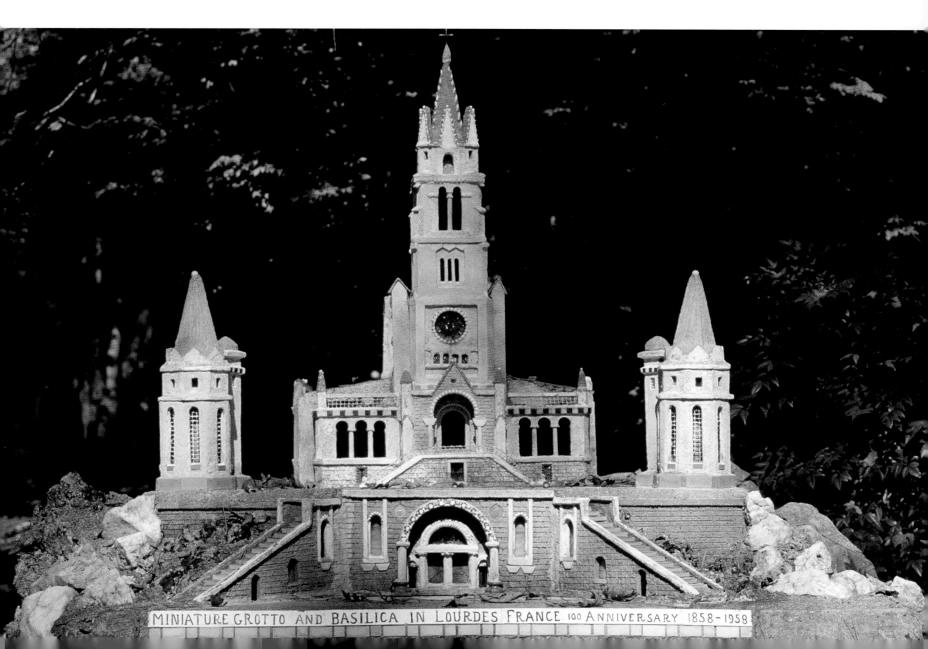

MINIATURE GROTTO AND BASILICA IN LOURDES FRANCE 100 ANNIVERSARY 1858-1958

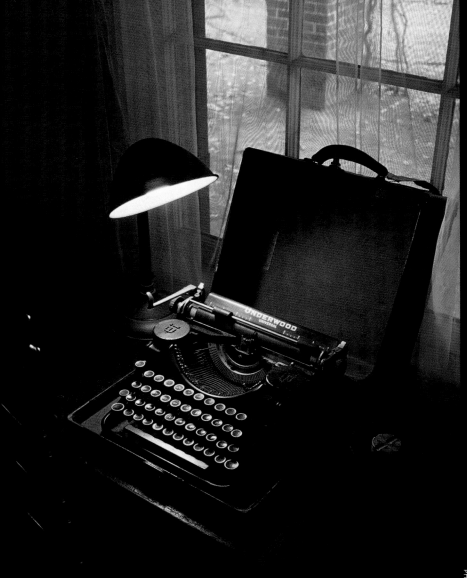

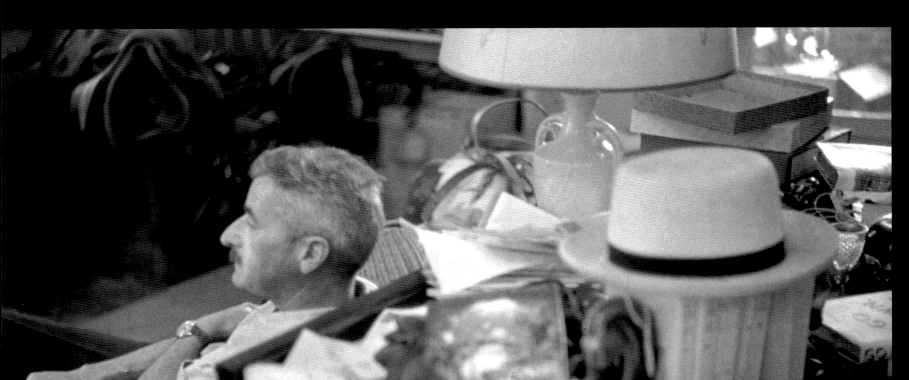

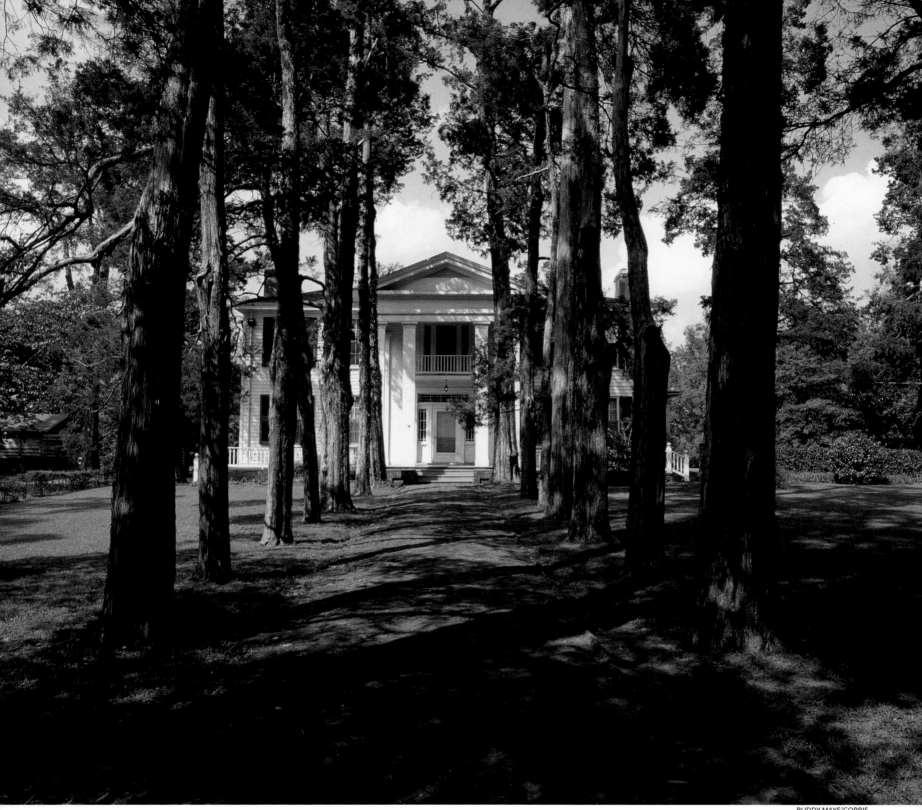

The Bard of Oxford

The rowan oak is a mythical tree, and it is somehow fitting that the Greek Revival house where the preeminent southern novelist and short-story writer William Faulkner created elaborate fictions is called **Rowan Oak**. In the four landscaped acres around the house and in the 29 acres of Bailey's Woods surrounding the estate in Oxford, there are impressive oaks indeed, as well as cedars, magnolias and walnut trees, and smaller plants—azaleas, roses and privet hedges—native to Mississippi. But there never was nor ever will be a rowan oak.

Faulkner (opposite, in 1947) bought the house, which was in poor shape, in 1930, and began fixing it up himself. It had been built by Col. Robert Sheegog in 1844, before the Civil War, and it seemed to Faulkner and his visitors the very embodiment of the word *antebellum*. The writer confided that Rowan Oak, where the past bled into the present, was a source of inspiration in his intricate storytelling, where time is often fluid, and where today's consequences are often found to be products of yesterday's truths. Rarely does a home seem so emphatically an extension of an artist's creation as does Rowan Oak.

The estate, which is now a National Historic Landmark owned by the University of Mississippi, can be toured. A guest can see the Underwood Universal Portable typewriter (opposite, top) upon which Faulkner crafted such masterworks as *Light in August* and *Absalom, Absalom!* You can even see, on the plaster walls of his study, the writer's notes. Scribbled there in pencil is the outline for a book that, in 1955, would win Faulkner the first of his two Pulitzer Prizes. The title of that novel—a very suitable title for a story wrought at a house called Rowan Oak—is *A Fable*.

OWEN FRANKEN/CORBIS

JAN BUTCHOFSKY-HOUSER/CORBIS

Hot Times on the Bayou

Champagne comes from the Champagne region in the northeast of France, and Dijon mustard originated not far from there, in the town of Dijon. Tabasco pepper sauce, on the other hand, comes not from the Mexican state of Tabasco but from an isolated part of Iberia Parish—a unique, strange island about 140 miles west of New Orleans that is named **Avery**, though it just as well could be called Tabasco.

The island, just inland from Vermilion Bay and the Gulf of Mexico, is a salt dome, and salt mining there predates even the manufacture of Tabasco. Edward McIlhenny married into the Avery family not long before the outbreak of the Civil War, and founded the McIlhenny Company to brew the sauce soon after the conflict ended. Avery Island's fertile soil, which had already supported a great variety of exotic plant life as well as a sugar plantation, proved perfect for cultivating peppers, and over the years the word *Tabasco* became synonymous with hot sauce.

Edward Avery "Mr. Ned" McIlhenny, a sauce-empire scion, was as dedicated to the island's wildlife and natural beauty as he was to the family business. In the 1890s, he noticed that hunters were killing snowy white egrets in great numbers to supply plumes for the ladies' fancy-hat trade. He gathered and raised eight young egrets, released them for their fall migration across the Gulf, then saw them return the next spring with more egrets.

Avery Island became a sanctuary for these birds and other avian life when Mr. Ned organized his Bird City preserve; today, the McIlhennys' 250-acre Jungle Gardens and Bird City, in which animal species from raccoon to alligator are protected and where camellias and azaleas proliferate, is an enchanted paradise enjoyed by visitors from the bayou and beyond.

As for Tabasco, it is still made daily in large quantities (opposite) from locally harvested peppers and ones grown elsewhere using Avery Island strains. From a singular place, a singular sauce.

Pickin' and Grinnin'

Classical music aficionados eventually find their way to Carnegie Hall, blues purists visit Chicago, and jazz pilgrims pay obeisance in New Orleans. When it comes to country and folk music, Nashville stakes its claim, of course, but Austin has much to offer too—and, frankly, so do variably authentic-Americana scenes in cities and towns across the land.

You enter **Mountain View**, however, and there is a naturalness to the musicality—a bred-in-the-bones quality; a song-might-break-out-at-any-minute vibe—that is unique to the point of being bizarre.

Does everyone in Mountain View, population circa 3,000, play? Pretty much. Mountain, folk and bluegrass music are in the air on a daily basis, whether on the stage at one of the so-called "pickin' barns," or on the front porch of any given downtown establishment. When folks in this small city in the Ozarks aren't harmonizing or tuning up, they're off crafting their own fiddles or they're stomping their feet and clapping along to one of the big acts, like the Del McCoury Band, that routinely blow through town to perform at a concert or festival hosted by the Ozark Folk Center. The locals say that as many as 100,000 flock to Mountain View for the festivals, but that's a trick of the light in a place this small—the number is probably half that. Mountain View is still a well-kept secret.

One thing about the music formally or informally performed here: It sounds genuine. There is no hat-act quality to the high lonesome tunes, there is real feeling—and there is a sense that this is what music meant to this community and many American communities a hundred or two hundred years ago. If you find yourself experiencing an *O Brother, Where Art Thou?* moment, you might well be in Mountain View.

BRUCE DALE/NATIONAL GEOGRAPHIC

BOB KRIST/CORBIS

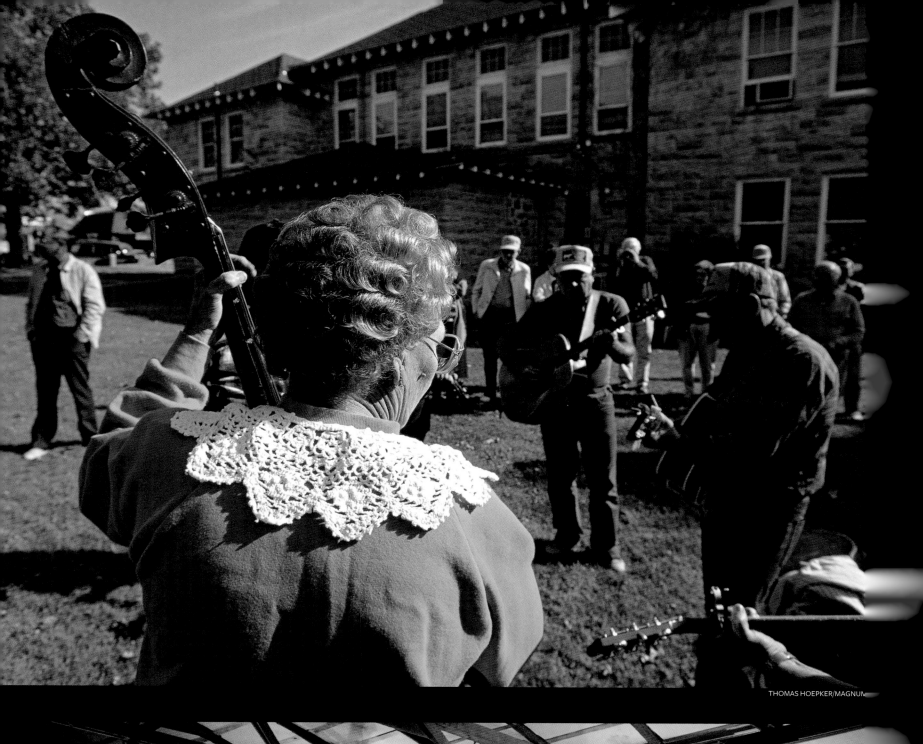
THOMAS HOEPKER/MAGNUM
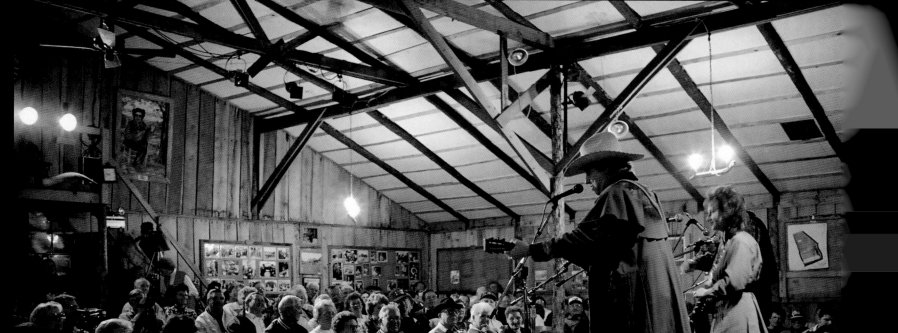

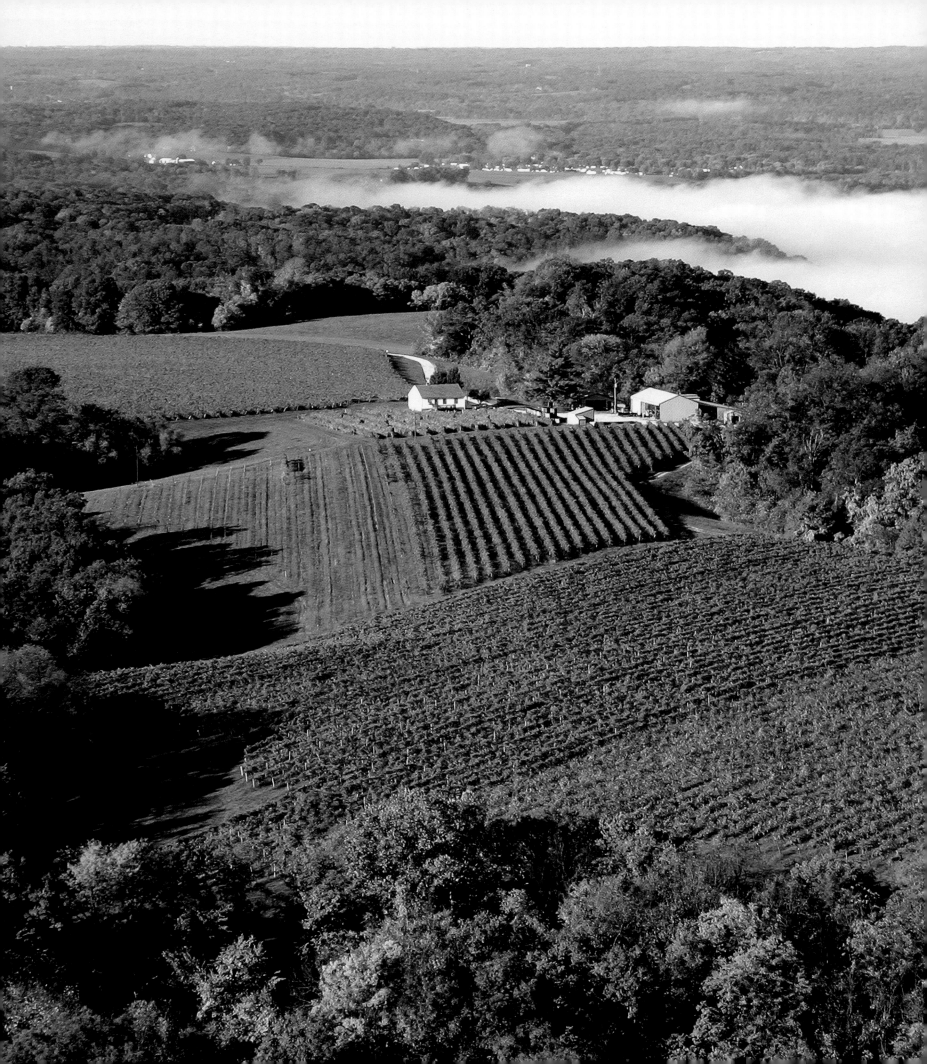

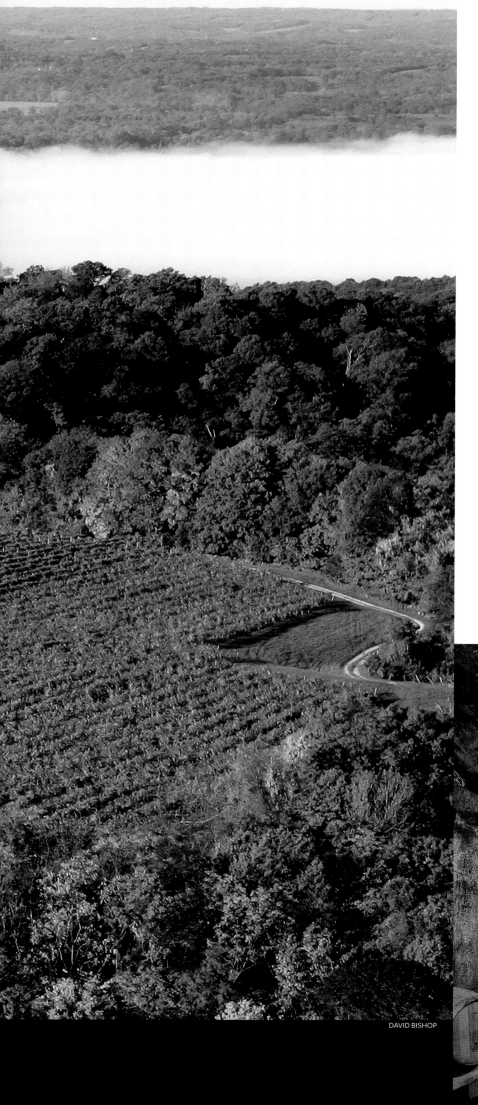

Napa of the Heartland

One of the tourist industry's most reliable offerings is the wine-country vacation or getaway. Fans of the grape will book their visits well in advance to the famous and not so famous vineyards of California's Napa and Sonoma valleys, to France's Bordeaux, to Italy's Tuscany, or to the winemaking regions of Australia and New Zealand. Beyond California in the U.S., bed-and-breakfasts do brisk weekend business in Oregon's wine country, in Washington State, and up the Hudson River or out on Long Island in New York State.

But Missouri?

Believe it: There's wine in them thar hills (and valleys) on either side of the Missouri River between the towns of St. Charles and Hermann, west of St. Louis. German immigrants settled in the region in the mid-1800s and brought with them their Rhineland traditions for planting and pressing grapes and making fine wines. Today, there are approximately 50 wineries in Missouri, several of them directly traceable to these first German vineyards and many of them along scenic State Highway 100.

The village of **Hermann** is a highlight, with its more than four dozen B&Bs signaling that it is a wine town ready, willing and able to rival even Napa for charm points. Visit the brick Hermannhof Winery on First Street, or the Stone Hill Winery (seen at left and below), dating to 1847, on the edge of town. At Christmastime, Hermann hosts a Weihnachtfest, a traditional German Christmas fete, and there is nothing more merry.

Even before the Germans settled, characters such as Lewis and Clark and Daniel Boone came this way. Particularly in and around St. Charles, this history is commemorated. So come to Missouri and celebrate a bounty of pioneers, of both the adventurous and winemaking kind.

JIM HARDING

DAVID BISHOP

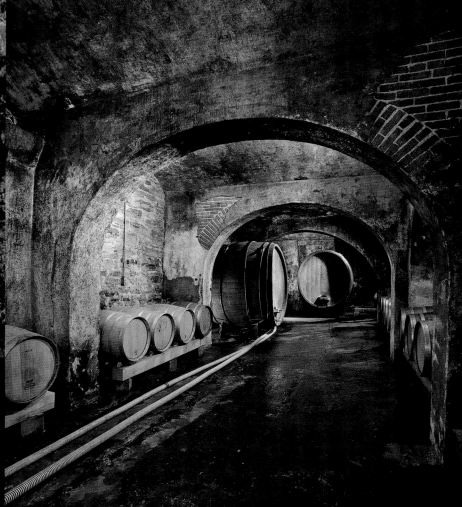

Burgers, California Style

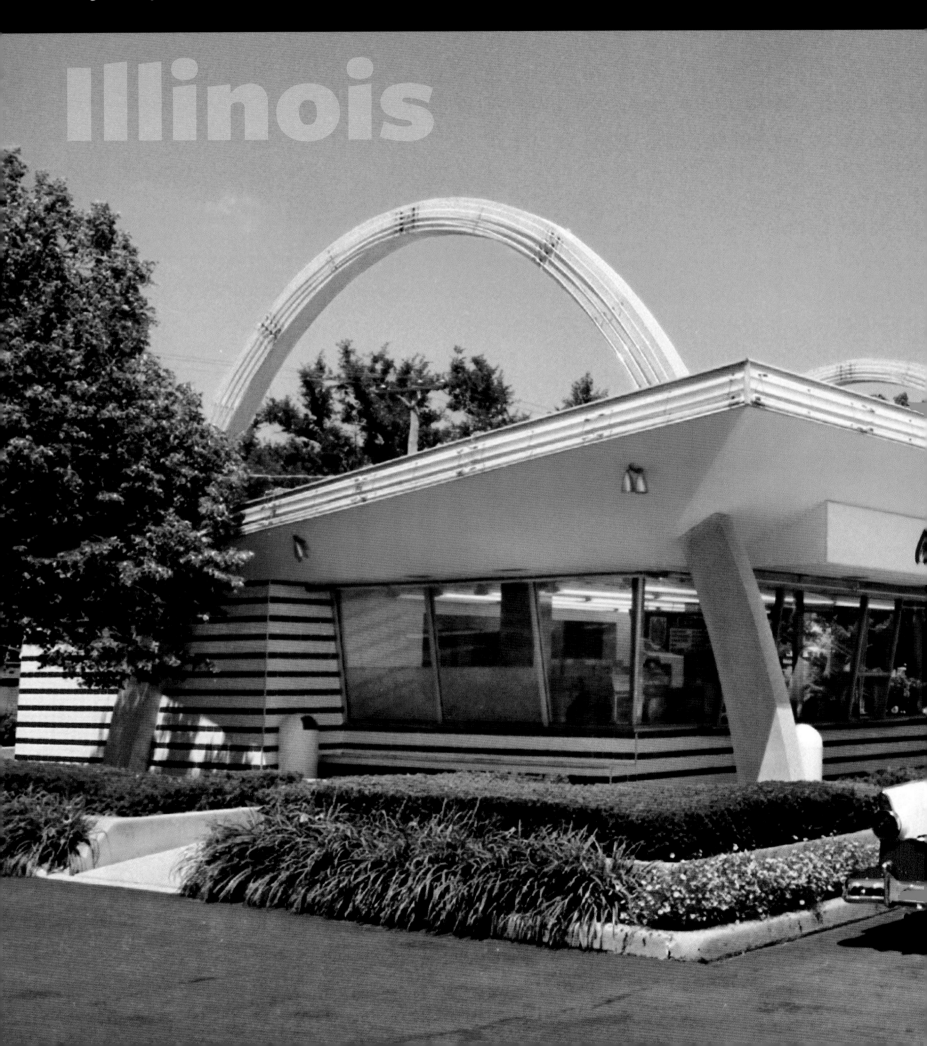

The operative wisdom is that fast food was invented in La-La Land, and that McDonald's, the Adam and Eve of burgers-and-fries chains, originated there. The operative wisdom is pretty much correct. But to cut short the wisdom at that point is to ignore the crucial role of **Des Plaines**, which today proudly claims its place in the history of expeditious gastronomy.

Ray Kroc was a 52-year-old salesman in 1954 who was investing his considerable energies in pushing the Multimixer, a five-spindled contraption that could churn out several milk shakes at a time. He heard that the McDonald brothers of San Bernardino, California, were running eight Multimixers at a time, and this he had to see. When he beheld the flood of young, suntanned humanity being served at McDonald's with rapid-fire efficiency, he saw the future. He suggested to Dick and Mac McDonald that they open several more of their burger joints, figuring each would be good for another eight

Multimixers? the Brothers asked, But who could open them for us.

"What about me?" Ray Kroc suggested.

Franchise Store Number 1 opened in Des Plaines, just west of Chicago, on April 15, 1955, and finished the day in the black with revenues of $366.12. McDonald's would never look back, and Kroc was on his way to becoming a billionaire.

Certain categories of Americana seem less than hallowed and hardly worth preserving, and progenitor fast-food joints would constitute such a category. Although the original Wendy's still stands in Columbus, Ohio, and the first Kentucky Fried Chicken outlet, the Harland Sanders Café, has been restored in Corbin, Kentucky, the earliest outlets of several other chains have vanished from the landscape. We are fortunate, therefore, to have the Des Plaines McDonald's still with us (below)—spiffed up to 1950s splendor and operating as a museum, replete with a set of Multimixers behind the counter. And should you get to feel a bit peckish during your visit, across the street is a fully functioning McDonald's.

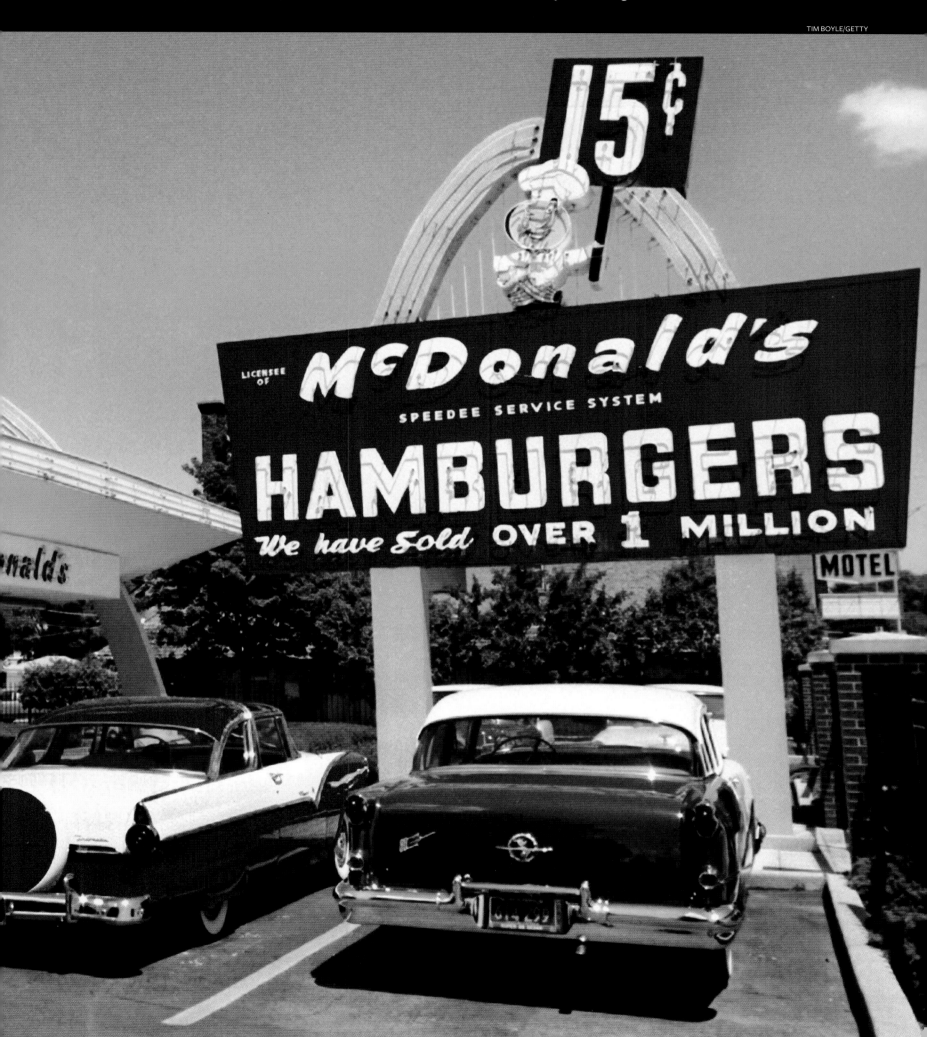

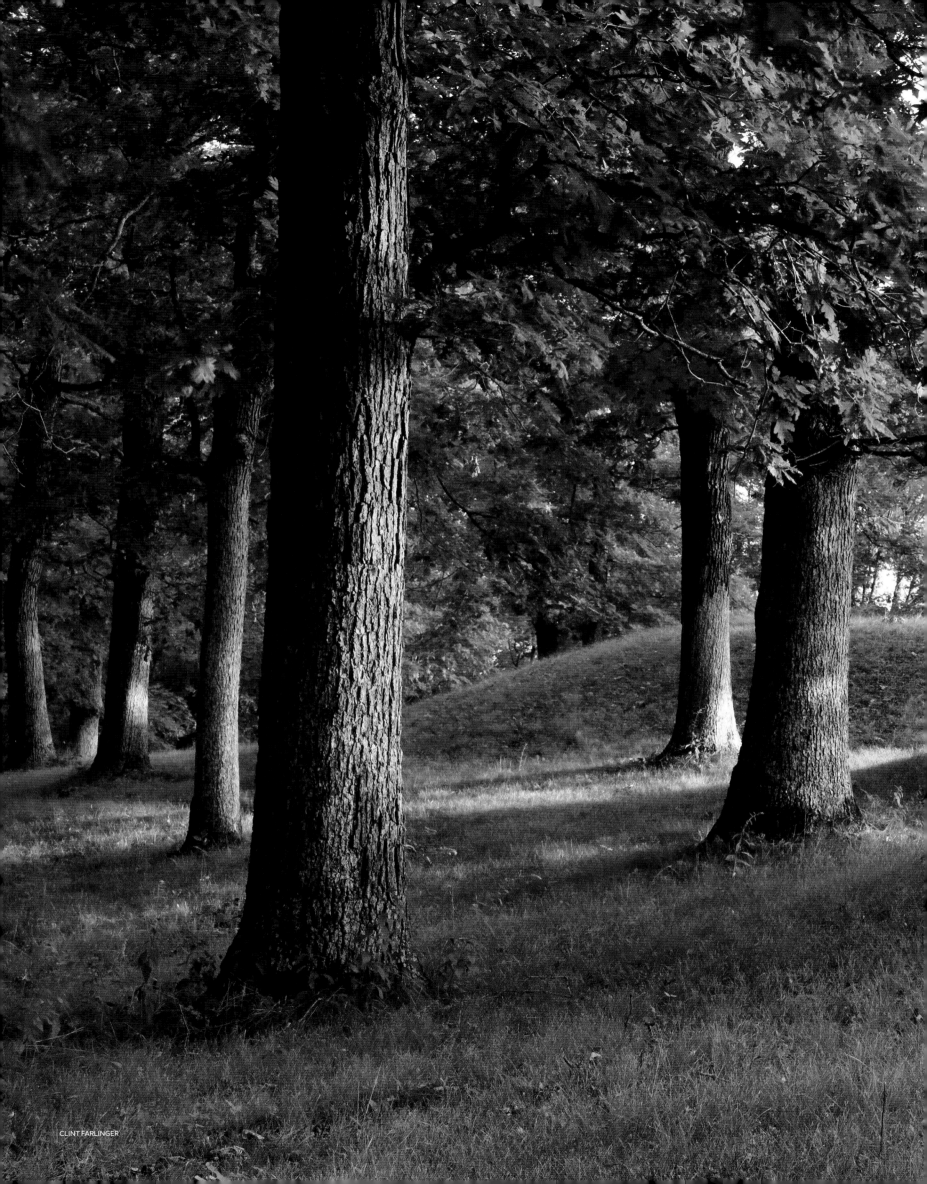

CLINT FARLINGER

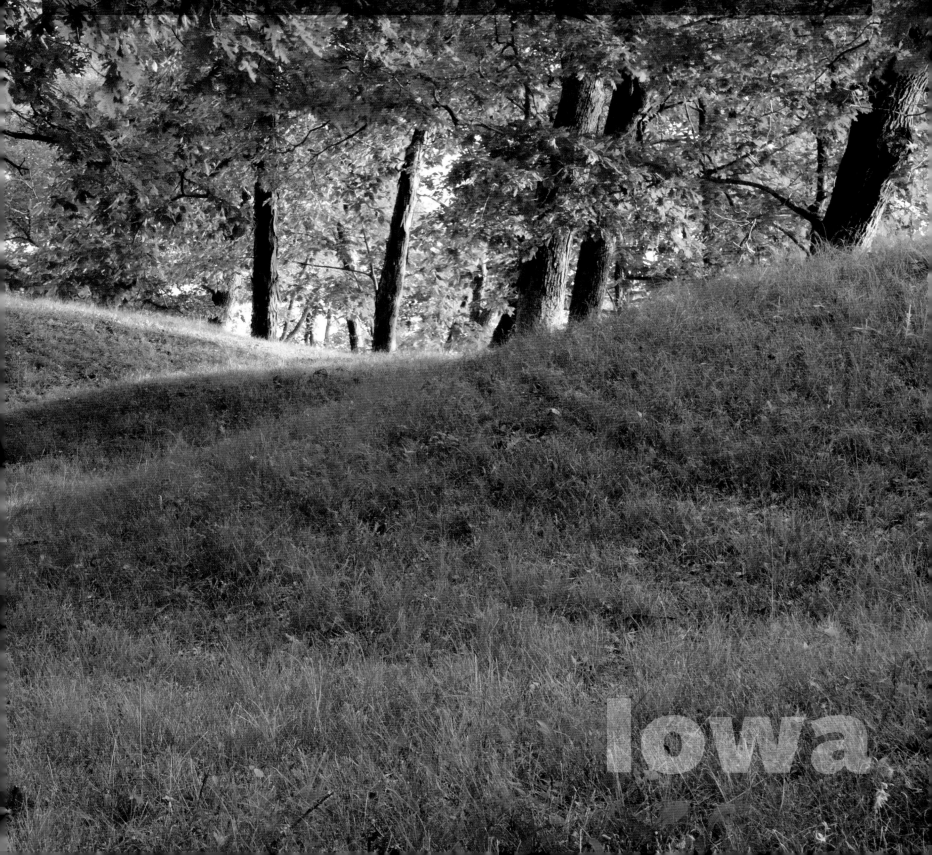

The Hills Harbor Secrets

While American history is well documented, the prehistory of America is often ignored. This is unfortunate since it is clear humans were firmly established in the New World thousands of years before the white man's arrival, and more should be known about the life the ancient inhabitants led.

These people built civilizations from Alaska to Georgia. Eventually, the hunter-gatherer lifestyle grew in sophistication, as evidenced by found tools, artifacts and earthworks. Most intriguing among the legacies are thousands of mounds throughout the U.S. Some were certainly burial places, some marked sacred sites.

On more than 2,500 acres in northeast Iowa, there are 213 mounds preserved at three locales near the Mississippi River. Of these slopes and undulations, 31 are effigies—representations of animals, many of which were associated with religious beliefs—and the official designation of this place is the **Effigy Mounds National Monument**.

It is pure serendipity that the mounds are still with us. As white settlers pushed west in the 19th century, they routinely disregarded any Native American sanctity and plowed under great swaths of mound-laced land in order to plant crops. But this place survived, not least because it was on higher ground that was hard to plow. It stands now as one of the largest known collections of mounds in the U.S., and as such it was designated a national monument on October 25, 1949—thus receiving eternal protection from development.

But what does it tell us?

Not enough.

The early inhabitants constructed mounds from about 500 B.C. onwards until just about the time the Europeans arrived, a period of nearly two millennia. Today, 16 Native American tribes are associated with the Monument, which they consider sacred, but it is not known for certain how many of these tribes might be directly related to the mound makers.

You walk this place, and the distant past whispers to you, but its words are not clear.

Iowa

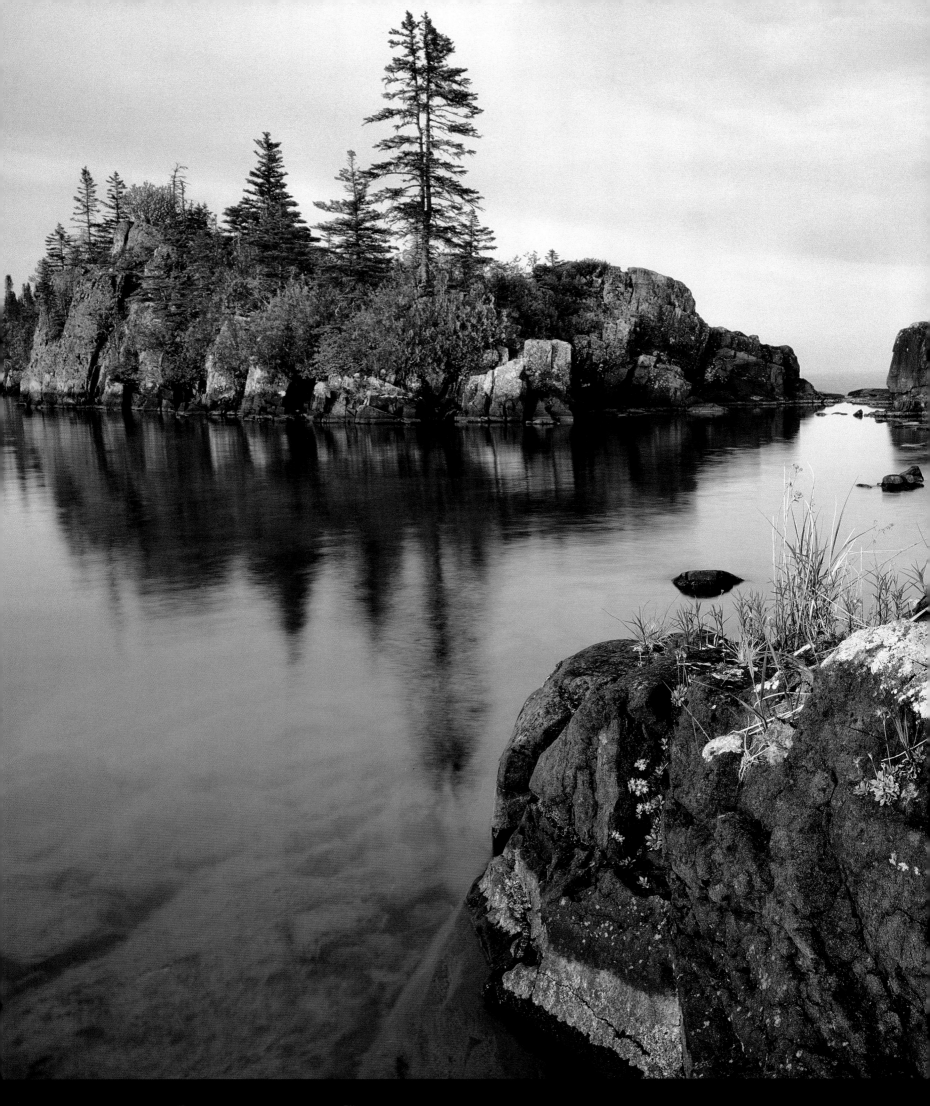

Michigan

Paradise Island . . . for Some

It is a national park that receives only 18,000 visits a year. (By contrast, Yellowstone receives 3.5 million and even, say, Acadia on the Maine Coast gets more than 2 million). Sitting in the far north of Lake Superior, it is much closer to the Canadian shore (only 15 miles) than to the U.S., yet the park belongs to us. The state it is closest to is Minnesota, but it is formally part of Michigan. The lake's water temperature rarely exceeds 54 degrees even in midsummer, and the air temperature on this big island (the country's 32nd largest, at 45 miles long by nine miles wide) almost never breaks 90. Dense fog is a hallmark. No people live here permanently; there are no roads here; in fact, no wheeled vehicles of any kind are allowed, save wheelchairs.

For all this, **Isle Royale** is, for a certain kind of nature lover, among the most beautiful, alluring places in the country, if not on the entire planet. For those who like hardy, vigorous and wild, this is the place for you.

Protected as a national park since 1940, Royale's Boreal Forest has largely covered over evidence of a copper-mining past, and today the island radiates a rugged good health. A hike up 1,394-foot Mount Desor is an invigorating experience, as is coming upon an inland lake, in whose depths thrive freshwater mussels, snails and a large collection of sponges.

There are rhythms and patterns here: of harsh weather sweeping in suddenly off the lake; of wolves and moose (bottom) in their predator-and-prey dance of mortality; of foxes (below) stealing into the campground at dawn; of a solitary individual proceeding slowly amidst great fir trees, lost in contemplation. No amount of marketing is going to make Isle Royale a vastly popular national park, but it is a beloved one to the smaller numbers that come here for something they find tantamount to a spiritual experience.

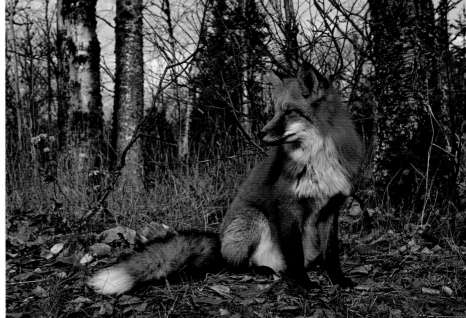

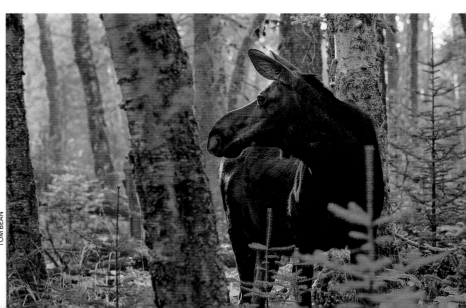

Wisconsin

A Town of Surprises

In the city of Tomah's Gillett Park, there is a museum called the Little Red Schoolhouse, and when you see it—the quintessential one-room school where children on the frontier were taught the three R's—you wonder if it is *the* Little Red Schoolhouse. Well, no, it's not; there are several others throughout the U.S., including ones in New York State, Arizona and Iowa, on the National Register of Historic Places that could make a better claim. In fact, Tomah's was called the Watermill School for more than a hundred years before it closed its doors in 1965. The city bought it, relocated it to the park and then painted it red.

Take a drive outside **Tomah** and you notice something else surprising: Amish children, carrying baskets. Yes, this isn't Pennsylvania or Ohio but Wisconsin, and the folks who began settling here in Tomah in 1966 now constitute the largest community of Amish in the state.

Now let's consider cranberries. In a bumper year, the national yield can exceed 350 billion berries. You would guess that Massachusetts, what with all those Thanksgiving pilgrims and the bogs of Cape Cod, is a big producer—and you would be right: The Bay State accounts for a quarter of the U.S. harvest. New Jersey, Oregon, Washington, Maine, Michigan and Minnesota each chip in smaller percentages.

But get this: Fully 50 percent of the country's cranberry crop is grown in Wisconsin, and good old Tomah, which is situated about midway between Minneapolis and Milwaukee in the center of the state, is known as "The Gateway to Cranberry Country." There are 2,000 acres of bogs in this region. Who knew?

There is no ocean spray in Tomah, but there are cranberries aplenty—and other surprises, too.

—GERALD BRIMACOMBE

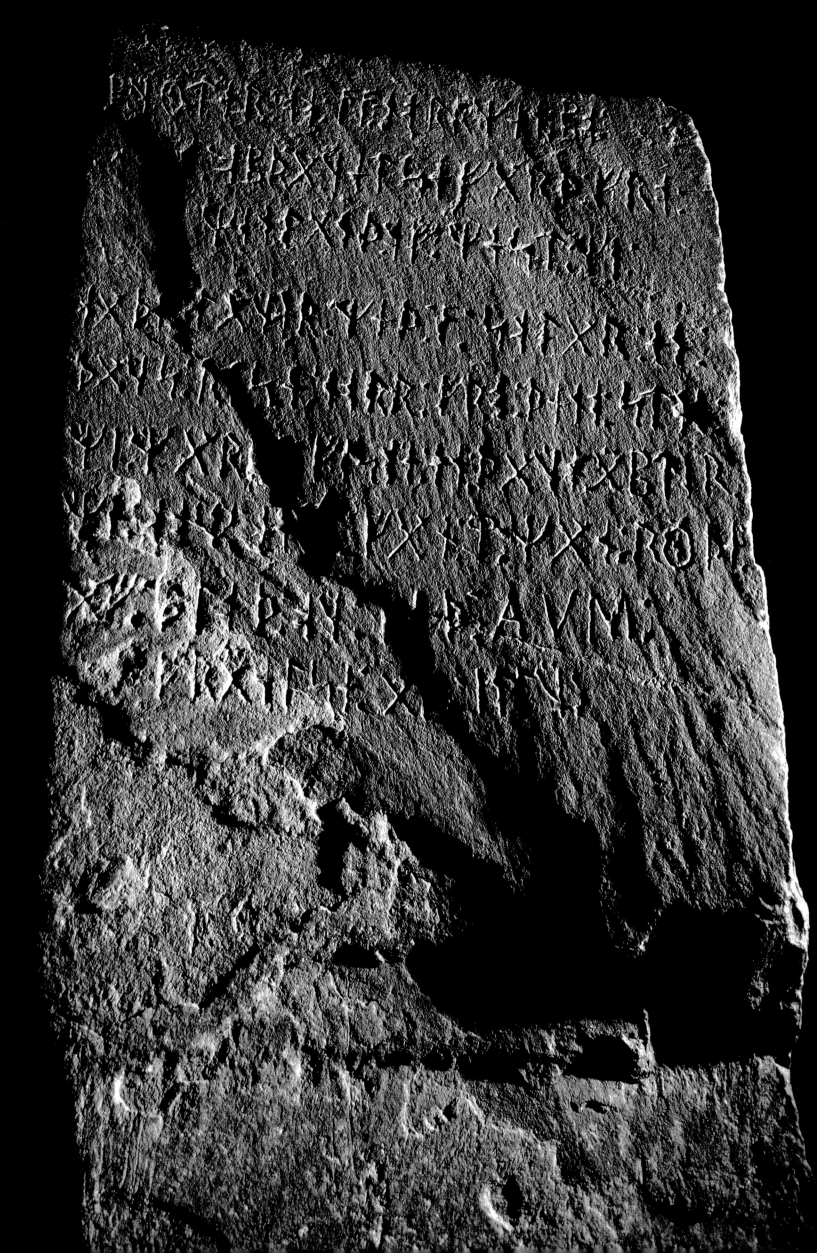

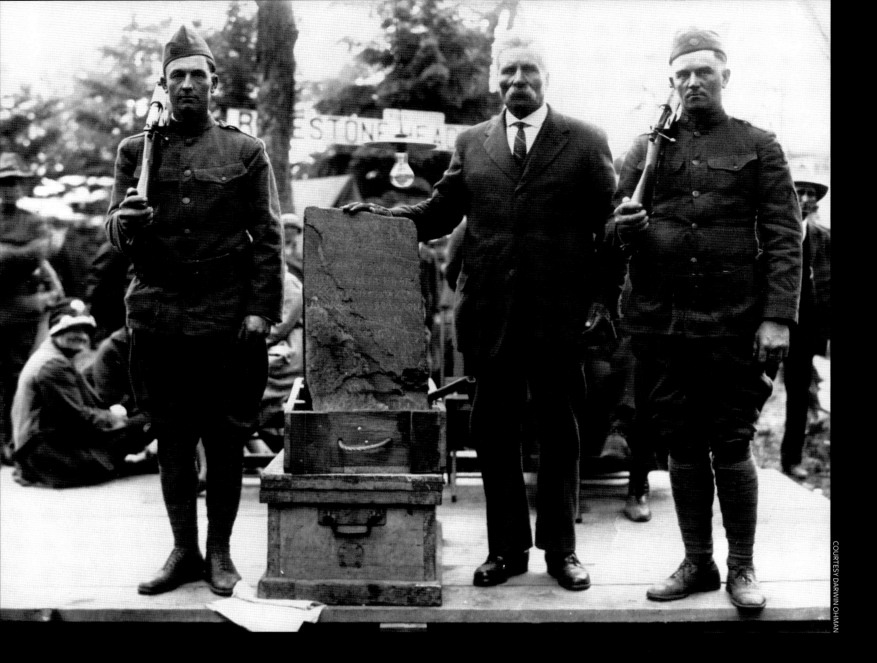

Why Rune a Good Story?

We are not here to dispute the authenticity of the **Kensington Runestone** (opposite). There are plenty of other folks more scholarly than us who are eager to dispute that, and if you travel even a little bit online you can find their learned arguments, as well as the passionate defenses mounted for the stone.

We're not entering the fray.

Our job in *Hidden America*, as we see it, is to talk about fascinating things that are authentic, and also about things that might be. If cryptic discoveries indicate that our country's prehistory may be other than we generally know it to be—well, then: This is the very heart of hidden America. Isn't it?

In 1898, Olof Ohman (above, center) and his son, Edward, were farming on land just outside Kensington (right) when they found something unusual. It was a slab of stone with strange markings on it. It mystified the town elders for years until a University of Wisconsin graduate student visited and deciphered the runic letters on the stone. He said the etched report told of eight Goths and 22 Norwegians traveling and exploring in this area in 1362, and at least 10 of them coming to a bloody end.

Did the Vikings come down from Hudson Bay as far south as this point in Minnesota in the 14th century? The Kensington Runestone certainly does not prove it to be so beyond all reasonable doubt, and in fact its detractors say it is most probably a 19th-century hoax. But in nearby Alexandria, where a Runestone Museum replete with a 28-foot-tall Viking statue (Big Ole) in the parking lot across the street has grown up around the stone, its authenticity is seen as rock solid—a

The Gentle Tribe

The Mandan were a tribe of Plains Indians who were different than most others. Mandan males could be warriors but were rarely the aggressors. Their villages usually consisted of about 50 earthen lodges situated around a sacred post that dominated a central plaza. The Mandan were content to stay in these established communities; and though they migrated up the Missouri River over several generations, they were not culturally nomadic, unlike most of the other tribes of the region. And they were dedicated farmers, which also set them apart. They grew corn principally, as well as beans, squash, sunflowers and even tobacco.

They were an old tribe, arriving in the plains of what is now South Dakota from points farther east as early as 900 A.D. Remnants of as many as 130 Mandan villages have been found by archaeologists along the Missouri. The best known of these today is in the Heart River area, the so-called **On-a-Slant Village** built on a slope descending to the river bed. It was discovered in 1937 and was determined to have been in use for perhaps a century beginning circa 1650. Today, replicas of six unique, spacious earthen lodges, including the one seen here, have been built on the site within Fort Abraham Lincoln State Park in Mandan.

The people of the tribe continued their slow progress north from On-a-Slant, surviving a smallpox epidemic and attacks from Assiniboin and Sioux Indians but with their numbers diminished. By the early 1800s, there was a Mandan village of about 1,250 established approximately 60 miles north of On-a-Slant, and it was with these hospitable Native Americans that the Lewis and Clark expedition wintered in 1804–05.

The Mandan helped America expand, but their interactions with the white man had terrible consequences when, in 1837, another smallpox plague reduced their population even more. The surviving Mandan merged with the Arikara and Hidatsa, and the identity and bloodline of this singular tribe diminished further.

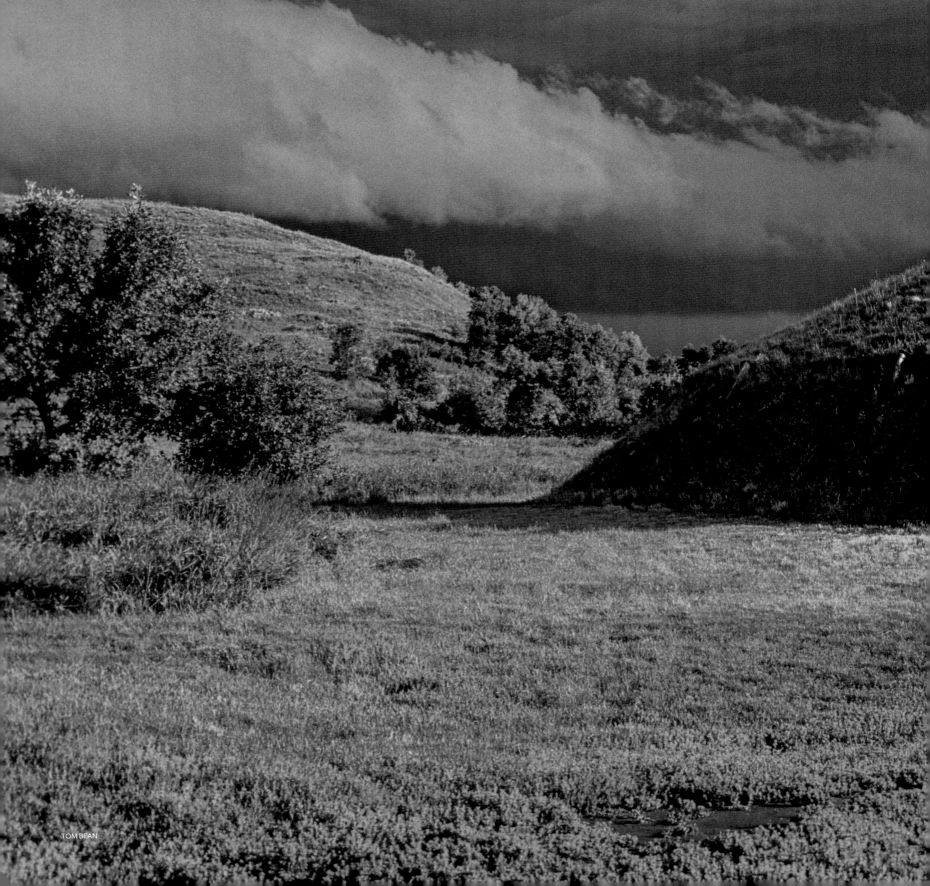

TOM BEAN

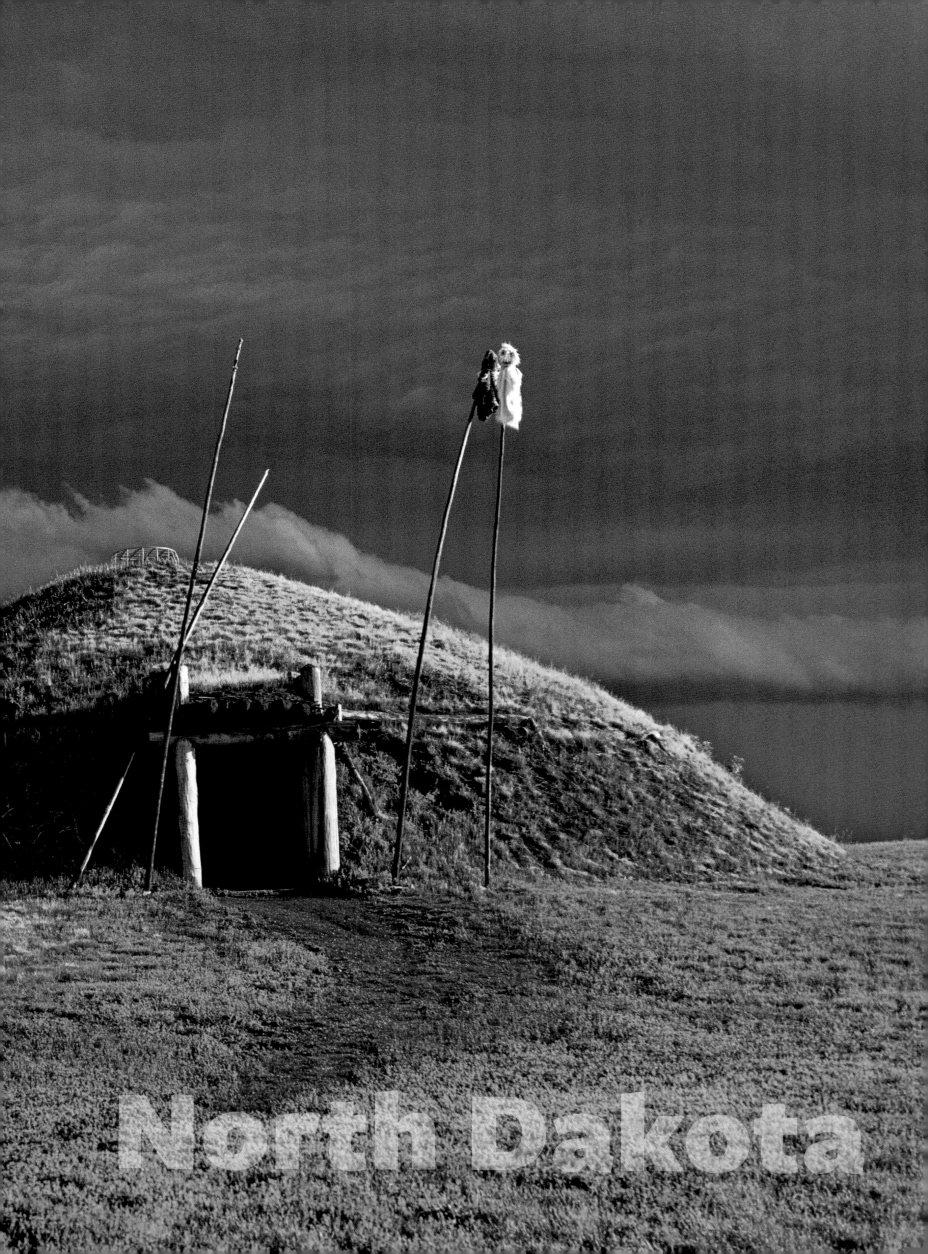

North Dakota

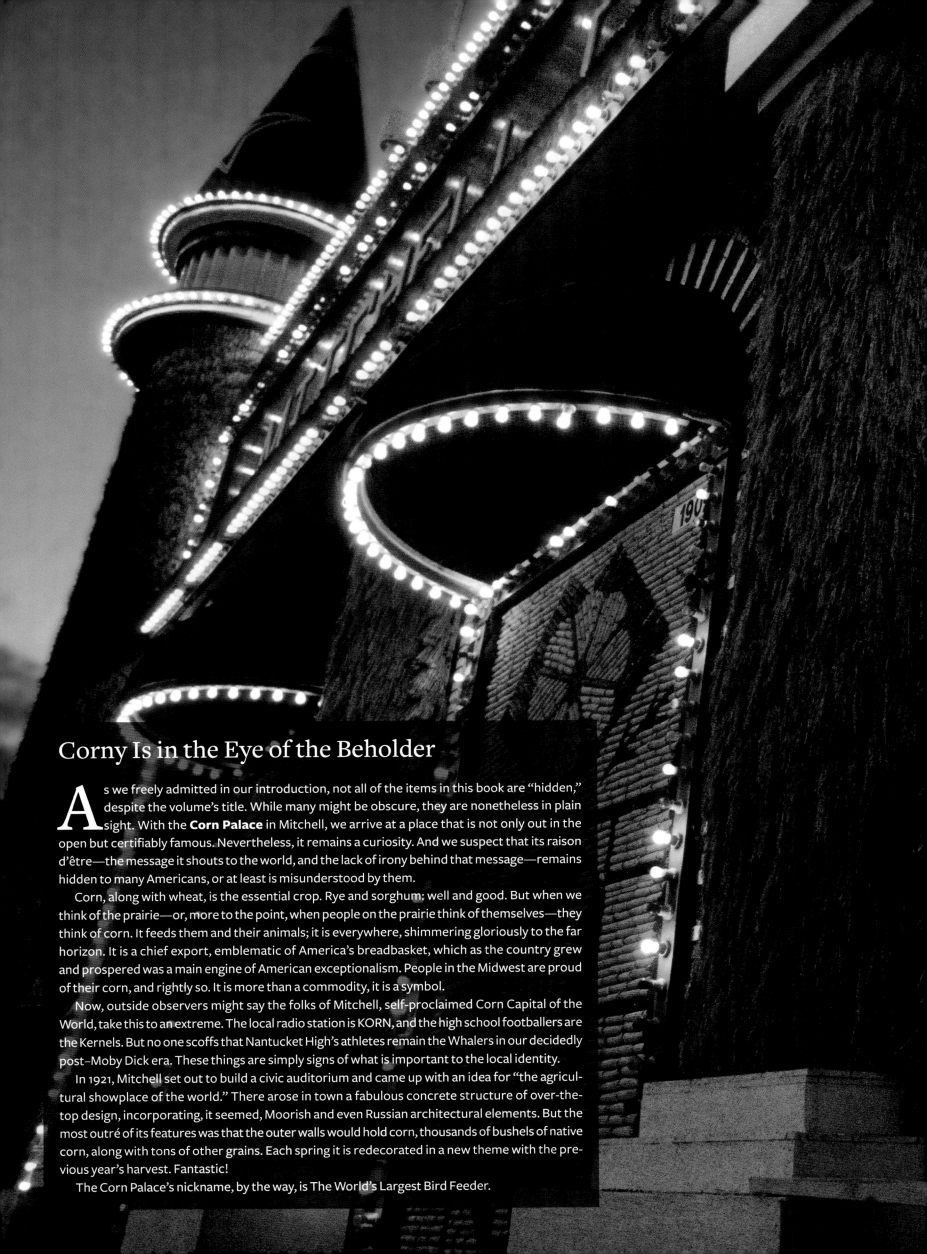

Corny Is in the Eye of the Beholder

As we freely admitted in our introduction, not all of the items in this book are "hidden," despite the volume's title. While many might be obscure, they are nonetheless in plain sight. With the **Corn Palace** in Mitchell, we arrive at a place that is not only out in the open but certifiably famous. Nevertheless, it remains a curiosity. And we suspect that its raison d'être—the message it shouts to the world, and the lack of irony behind that message—remains hidden to many Americans, or at least is misunderstood by them.

Corn, along with wheat, is the essential crop. Rye and sorghum: well and good. But when we think of the prairie—or, more to the point, when people on the prairie think of themselves—they think of corn. It feeds them and their animals; it is everywhere, shimmering gloriously to the far horizon. It is a chief export, emblematic of America's breadbasket, which as the country grew and prospered was a main engine of American exceptionalism. People in the Midwest are proud of their corn, and rightly so. It is more than a commodity, it is a symbol.

Now, outside observers might say the folks of Mitchell, self-proclaimed Corn Capital of the World, take this to an extreme. The local radio station is KORN, and the high school footballers are the Kernels. But no one scoffs that Nantucket High's athletes remain the Whalers in our decidedly post–Moby Dick era. These things are simply signs of what is important to the local identity.

In 1921, Mitchell set out to build a civic auditorium and came up with an idea for "the agricultural showplace of the world." There arose in town a fabulous concrete structure of over-the-top design, incorporating, it seemed, Moorish and even Russian architectural elements. But the most outré of its features was that the outer walls would hold corn, thousands of bushels of native corn, along with tons of other grains. Each spring it is redecorated in a new theme with the previous year's harvest. Fantastic!

The Corn Palace's nickname, by the way, is The World's Largest Bird Feeder.

South Dakota

Nebraska

A Beacon

What purpose did this striking natural sentinel serve in the westward movement of the United States? A crucial one. Today, it is scenery, beguiling scenery. In the 19th century it was as if God had placed a guidepost of sorts on the far side of Nebraska.

Fur traders and mountain men were among the brave few in the early 1800s (like Lewis and Clark) who blazed a trail to the West. But in the 1840s, one of the greatest voluntary migrations in history got under way when midwestern farmers became intrigued by the richness of Oregon's Willamette Valley. After preparing all winter for the 2,000 mile, half-year journey, families usually gathered in small parties at Independence, Missouri, near the great river. From there, they set off into a brave new world.

The Oregon Trail was 10 miles wide in some places; in others, a cart could just squeeze by. Some 300,000 emigrants made the grinding trip, usually in covered wagons pulled by oxen. Women would fill the butter churns and hang them off the back; the road would be rough enough to process a bit of butter for supper.

Difficulty was expected on any given day. Despair and danger, too, visited at regular intervals. But the intrepid pressed on, hoping for a sign.

For many, that sign rose from the prairie floor in western Nebraska: **Chimney Rock**, visible from 40 miles away. It was a key landmark for the pioneers, and word of what it meant had been passed back down the line to Independence. What Chimney Rock said was: You're getting there!

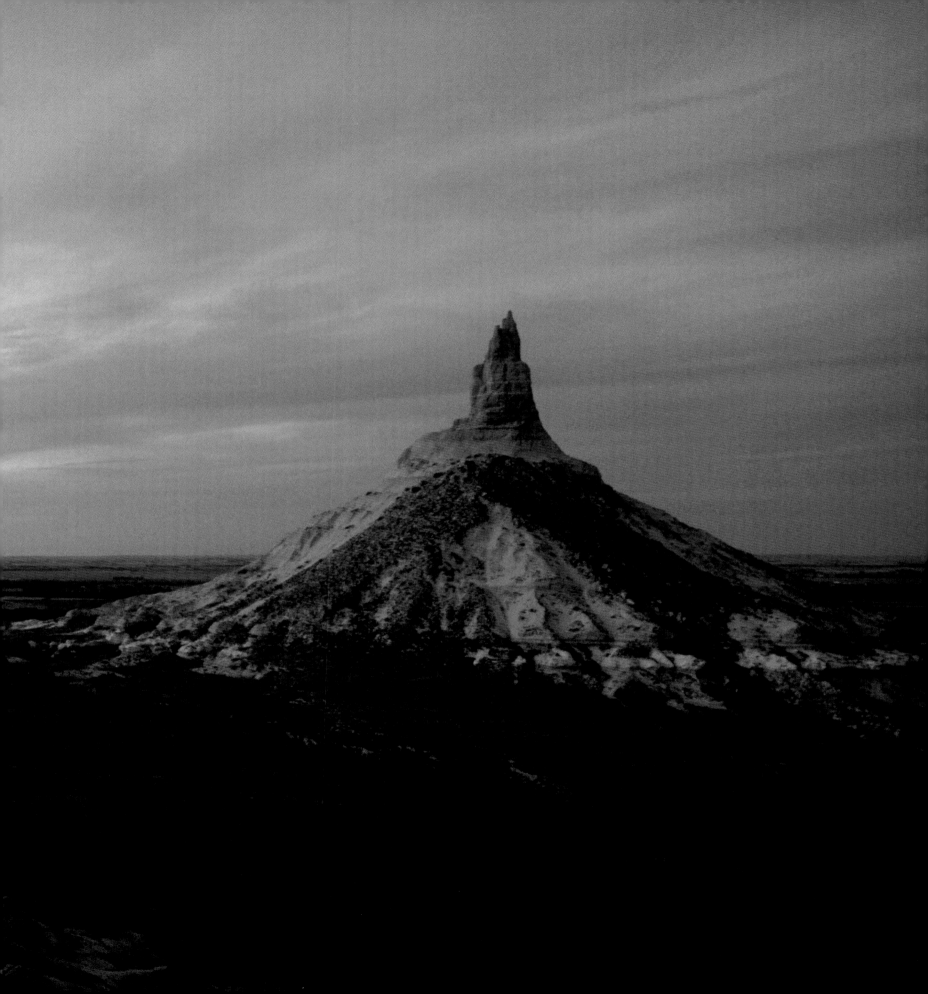

CHARLIE RIEDEL

JON BLUMB

Don't Eat the Apples

In the small farm town of Lucas there is, in the yard of a house two blocks off the main street, what you would call a showstopper. Surrounding an edifice made of limestone slabs that have been fashioned to look like logs is a tangled forest of some 45 concrete sculptures ranging up to three stories in height. Although only some of the figures are biblical, including a welcoming Adam and Eve at the side gate, the name of this artistic phantasmagoria is **The Garden of Eden**. It has been a central-Kansas mecca for fans of roadside curiosities for more than a century.

One man and one man alone is responsible for the Garden. Samuel Perry Dinsmoor was born in 1843 in Ohio and served in the Civil War as a nurse for the Union Army. Following the war, he became a schoolteacher, joined the Masons, got into the Free Thought movement, married, fathered a number of children and then moved with his family to the outskirts of Lucas and settled into the farm life. After a few years of that, he bought a plot nearer the town center in 1905 and built his odd limestone Cabin Home upon it. Then he started to grow his concrete garden, which would eventually, on its completion in 1928, weigh in at a ponderous 113 tons.

It was always intended to reflect Dinsmoor's social philosophies as much as his religious principles, so while there are angels and a devil, you'll also find an evil banker, a lawyer and a doctor. An octopus symbolizing monopolies tries to encircle the globe. A second octopus representing a corrupt trust is speared by Lady Liberty in another graphic scene.

The Garden seems from the first to have been intended as a public attraction—as well as a source of income. Dinsmoor threw open the gate in 1908, and tours are still offered year-round. One of the tour highlights is a 40-foot-high limestone mausoleum in one corner of the yard. Visible in a glass-sided coffin is the well-embalmed Dinsmoor, who died in 1933. Visitors can pay proper respects there to the eccentric sculptor who provided their afternoon's entertainment.

Twilight

While Tom Sawyer and Becky Thatcher thought they had big problems in that bat cave in Missouri, they might have considered themselves lucky indeed had they ever stumbled into the one in **Selman**. There, each spring, a huge colony of Mexican free-tailed bats migrates more than 1,240 miles from south of the border so that the females can hunker in the cave and give birth to their young. Before the bats return to Mexico in the autumn, they put on a spectacular nightly show in the skies over the Oklahoma prairie. As the sun sets, they begin to emerge from the cave—the shrieking advance guard, and then the overwhelming flood of an ink-black bat army about a million strong. They have come forth to feed, and once the pups are flying, they will do so continuously for the next eight hours at distances as much as 60 miles from the cave. During this time the bats, a farmer's best friend, will consume some 10 tons of insects, mostly mosquitoes, beetles and moths. Then these creatures of the night will return to the cave at dawn, and sleep.

Consider the bat, one of the planet's most famous, notorious and ubiquitous critters. The thousand species of bats, divided into vegetarians and carnivores and ranging in wingspan from six inches (the bumblebee bat) to six feet (the flying fox), account for fully a quarter of all mammalian species on earth. They are everywhere, they are plentiful and—as Oklahoma growers will tell you—they are not the villains they are often made out to be. Some bats eat up to 600 bugs an hour when feeding. Perhaps evolved 100 million years ago from a nonflying squirrel-like mammal that leapt from tree to tree, certain bats had more skin between their arms and body that, when flapped, allowed them to rise and glide. Altogether: a fantastic creature.

And in Selman: a fantastic display.

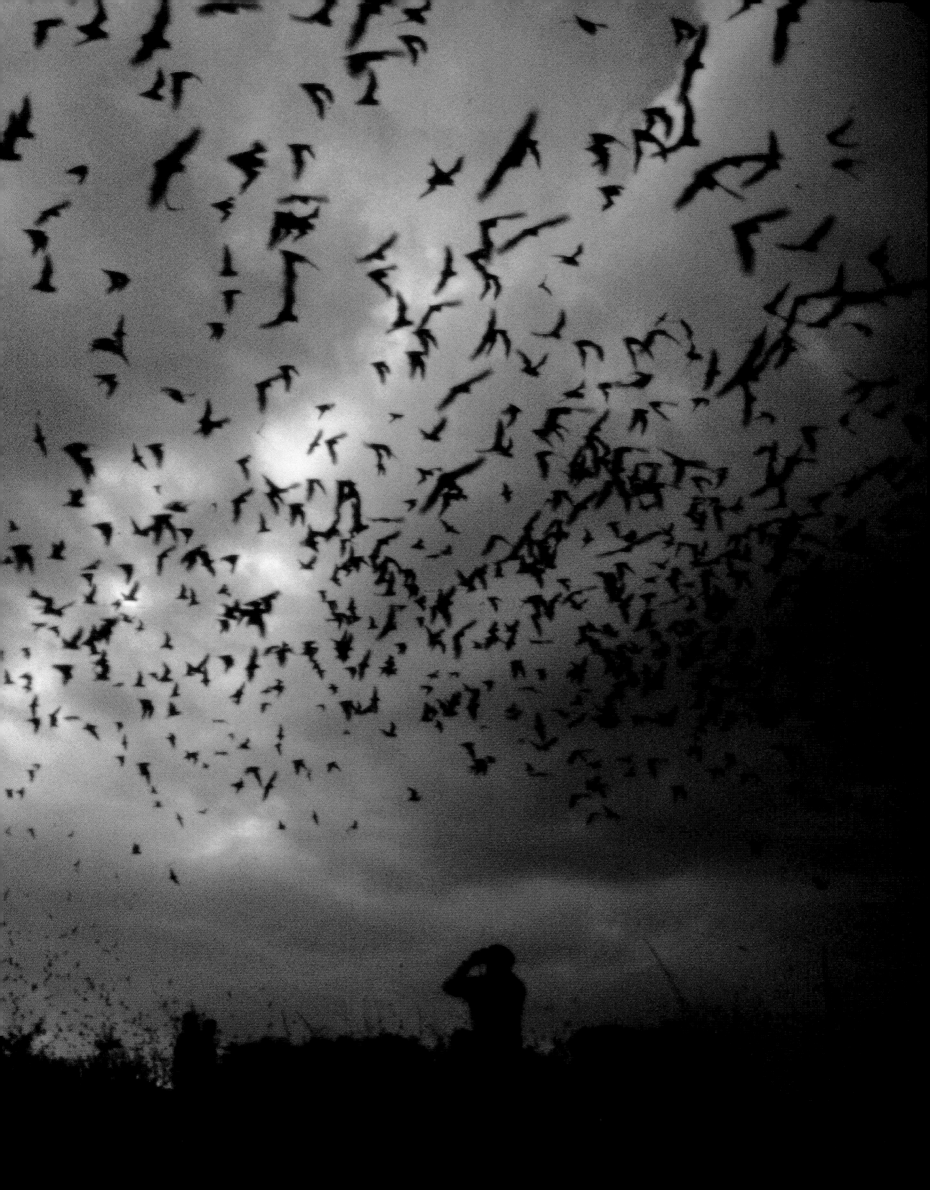

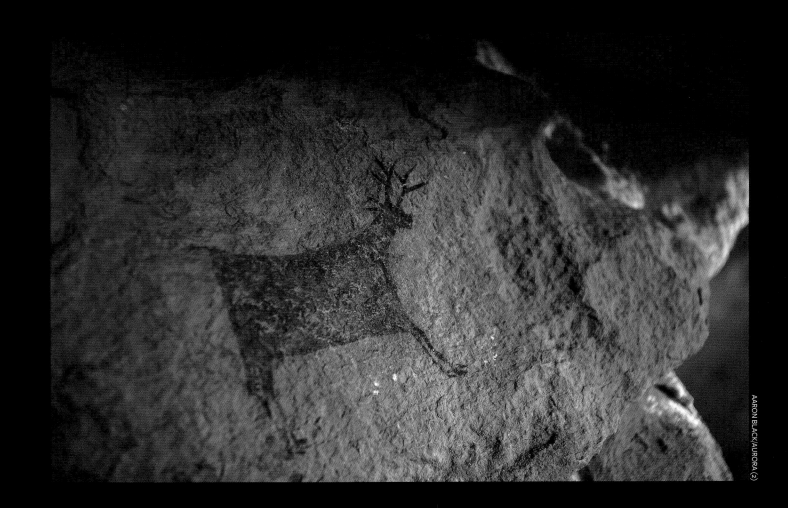

Signs

History ancient and much more modern is signaled in two Texas sites—one extremely wild and, in some of its most alluring sections, hard to access; one right downtown.

In rugged terrain 32 miles northeast of El Paso is the **Hueco Tanks State Historic Site**, an 860-acre park highlighted by some 2,000 rock paintings called pictographs that were created by the people who lived here thousands of years ago and more recently by Mescalero Apaches. These illustrations, many of which tell narrative tales, include more than 200 face masks made by members of the prehistoric Jornada Mogollon culture. They are fantastic, but much less well known and more seldom seen than the pictographs left behind more than 1,300 years ago by the Anasazi culture at other sites in the American West. Why? Because getting to some of the best Hueco Tanks drawings requires clambering over rocky mounds, treading carefully on steep slopes, or squeezing into crevices. For those with a double interest in vigorous exercise or even rock climbing as well as cultural anthropology, Hueco Tanks is essential one-stop shopping.

For many other citizens, a trip to the part of Dallas where President John F. Kennedy was assassinated on November 22, 1963, is a painful but necessary pilgrimage. This is perhaps the most over-analyzed neighborhood in the country. Conspiracy theorists have never accepted that Lee Harvey Oswald, acting alone, successfully carried out the murder, shooting with a rifle from a sixth-floor window of the Texas School Book Depository—as the official record and several detailed investigations have concluded. Visitors today can see the Depository building, the grassy knoll and, thanks to an X placed on **Elm Street** by local Kennedy-assassination researchers, the spot where the fatal shot struck the President as he sat in his open-topped limousine.

Sands of Time

Dude, the sand-surfing's awesome!

That was not what Spanish explorers exclaimed 400 years ago when they came upon these hills of sand extending to the horizon in west Texas. Were they to venture to this place today, that might represent their sentiments precisely; sand-surfing along with camping, hiking, picnicking and bird- and wildlife-watching are among the principal recreations at **Monahans Sandhills State Park**. But back then, it was just an astonishing expanse of sand, all the more remarkable for how it pops up in Texas.

The dune field here is 200 miles in length, stretching north into New Mexico. The area gets barely 12 inches of rain per year, but there is fresh water beneath the sands and therefore the sandhills have been a hospitable environment for people passing through. The native peoples have favored this place for centuries as a temporary camp site and a range for hunting. Today, the animals still come. There is sometimes water in shallow ponds between the dunes, and a visitor can watch mule deer, gray fox, coyote, bobcat, wild hog, porcupine, jack rabbit and (watch out!) skunk arrive at such water holes to drink.

The Monahans Sandhills are not famous like Death Valley or Joshua Tree National Park, but they are impressive and, in the way of those other realms, inspirational. Amidst these dunes, time stands still. The breeze blows, and contemplation is the order of the hour. This is a beautiful and somewhat eerie land, a place like no other.

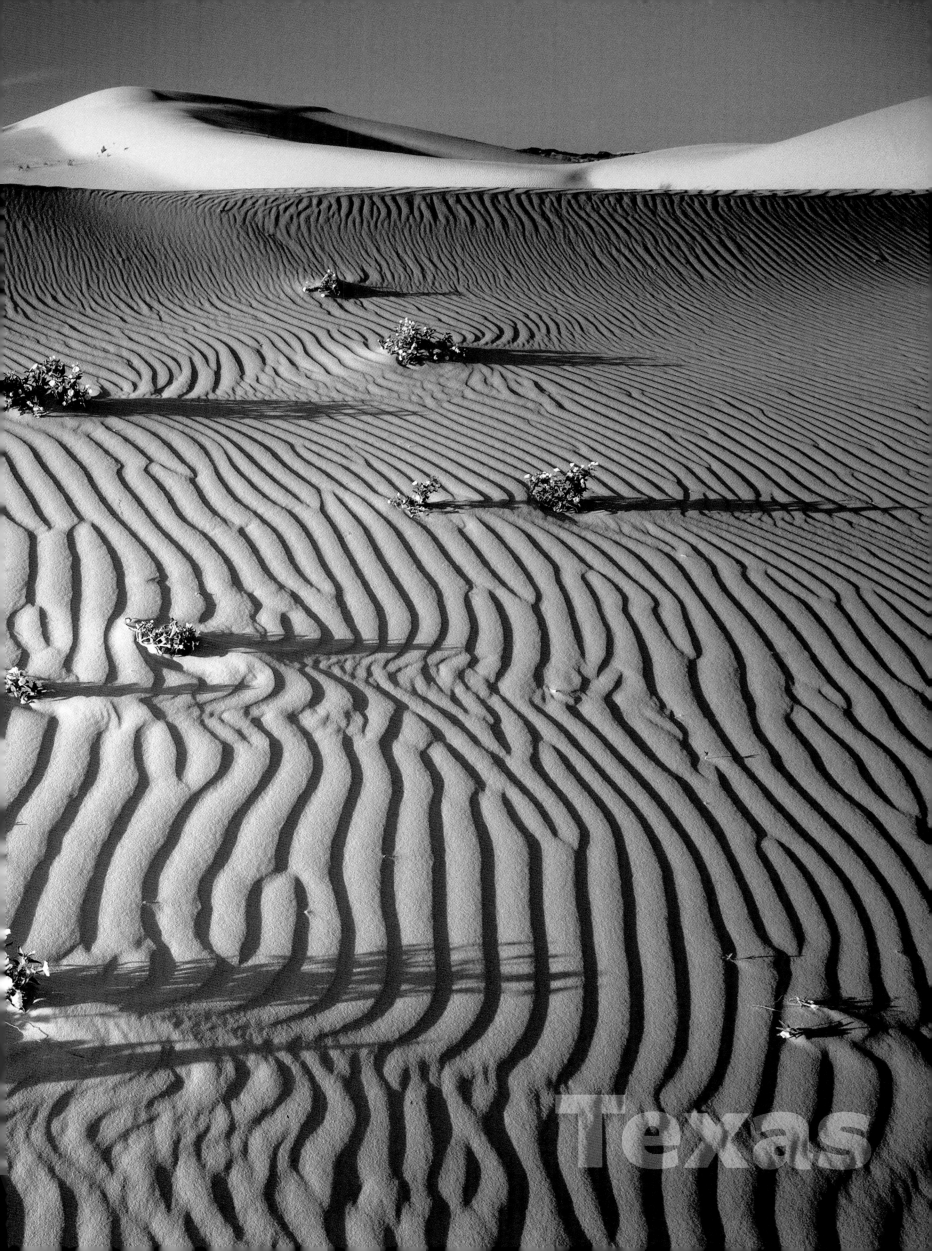

Texas

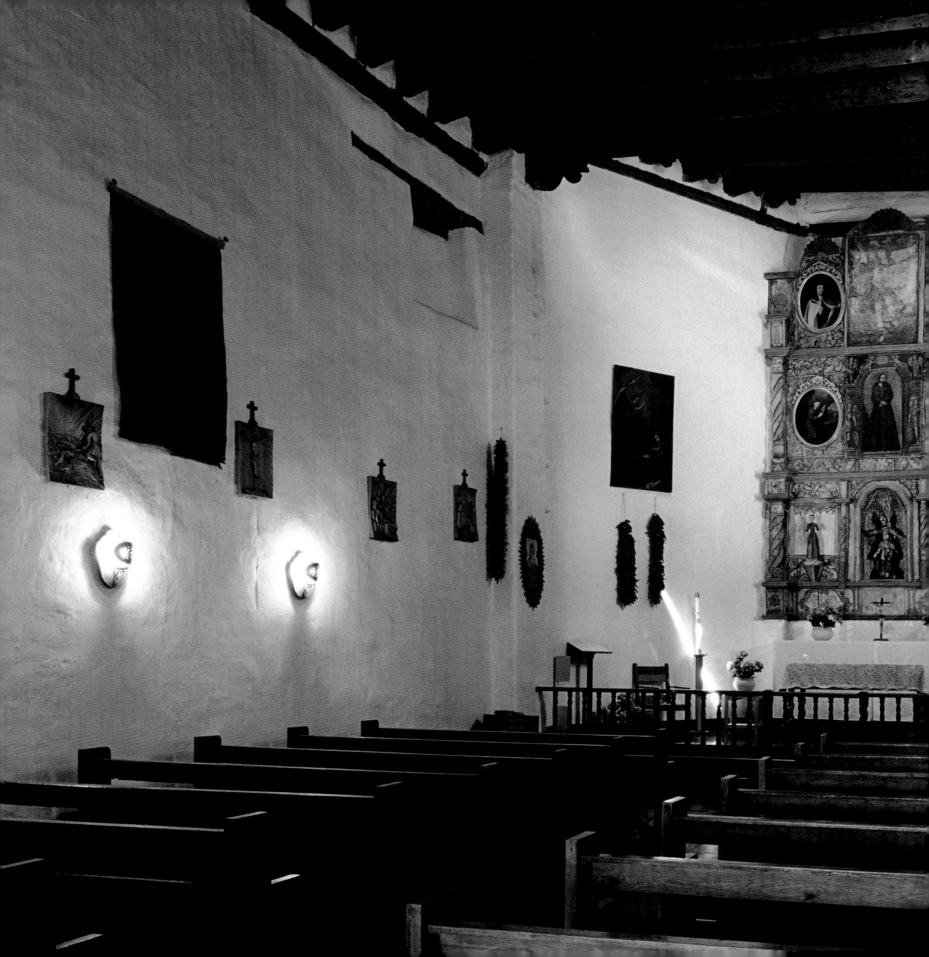

GERALD BRIMACOMBE

Christ's Arrival in the West

T he sign at **San Miguel Mission** in Santa Fe reads: "Oldest church structure in the U.S. The original adobe walls and altar were built by Tlaxcala Indians from Mexico under the direction of Franciscan Padres, ca. 1610." It is a carefully worded claim—"church structure"; "original" walls and altar—because much has happened to this beautiful house of worship since it was first built between 1610 and 1626. That's careful wording too: "first built." The chapel was badly damaged during the Pueblo Revolt of 1680, but the windows and the thick adobe walls withstood the assault. The church was rebuilt in 1710 after the Spanish reconquest of Santa Fe, and subsequent additions and renovations have further altered the original; the tower, for instance, is a remodeled version (above). But Mass is still said in San Miguel today, and since the strong walls have served to gather Christian worshippers for nearly four centuries, the chapel can make a very reasonable claim as the oldest existing church still in use in the New World.

Just as San Miguel has changed through the decades, it has served very different congregations. Its first incarnation was as a mission for poor, mostly Mexican Indians who joined the Santa Fe congregation. After its 1710 resurrection, it was used as a church for the Spanish soldiers. In the mid-19th century, Archbishop Jean Baptiste Lamy led the Christian Brothers over the Santa Fe Trail to start a school for boys, which became the adjacent St. Michael's High School and College, and to use the chapel.

Today, the church provides a reasonably authentic nod to its roots, and a fascinating if brief survey of Christianity's role in the West. The fabulous altar screen, remodeled during the 1800s, has been faithfully restored (left). A statue of Saint Michael that was sculpted in Mexico in 1709 is another highlight.

The structure itself and the accoutrements are from many eras, but they reflect a continuity of worship that is nearly two centuries older than the country itself.

R. KRUBNER/ROBERTSTOCK

Riding the Rails Into the Past

Today it is called the **Durango & Silverton Narrow Gauge Railroad & Museum**, and the principal objective of the operation is to shuttle tourists through some of the most impossibly beautiful mountain scenery in the world in restored railcars drawn by circa-1925 coal-burning locomotives. It might be assumed that once upon a time this was a "real" railroad with real needs as regards transporting people and materials. While this assumption is certainly correct, it is interesting to look at the original intentions of the Denver & Rio Grande Railway when it was formulating its plans for the Colorado high country back in 1881. Certainly the underlying economic rationale for the railroad was to get the tons of gold and silver being mined in the mountains to market, and it is estimated that more than $300 million in precious metal was transported over this route before the mines played out later in the 19th century.

But from the very first, the train's operators sensed the tourist marvel they were sitting on. How could they not, needing only to look out the windows? When the tracks to Silverton opened in July of 1882, they were promoted not just as an industrial proposition but as a scenic recreational opportunity for the individual traveler. Unbeknownst to Silverton executives back then, on this subsidiary raison d'être rested the railroad's long-term future. And it is the sole reason the Durango & Silverton is still with us.

The railroad survived mountain slides, times of boom and bust, track closures and reopenings, extended spells of dormancy along large sections of the line and even a period of government ownership before settling into an exclusive mission as a tourist train. Interestingly, when things looked bad for the railroad in the mid- and late-20th century, an angel arrived from, of all places, Hollywood. As you peer from your vintage seat, you might think: This looks just like something out of *Viva Zapata* or *Butch Cassidy and the Sundance Kid*. You would be right, as the railroad has played a supporting role in any number of westerns.

Faux Pharaohs

When the folks at RoadsideAmerica.com visited the **Ames Brothers Pyramid** off a dusty dirt track in Buford, they were told about the ease of its maintenance by Bill Conner, the local parks superintendent: "It's not really a problem for us because most people don't know about it."

The situation was not always thus. In fact, when the pyramid was dedicated in the mid-1880s, former President Rutherford B. Hayes traveled here to grace the proceedings.

Why in the world would he do so? Who in the world were the Ames brothers? Why, for goodness sake, is there a 60-foot-square, 60-foot-high, totally empty pyramid in the middle of nowhere?

Good questions all.

The Ames brothers, Oliver and Oakes, were socially and politically prominent easterners who made a fortune selling shovels during the California gold rush and used that money to acquire a controlling interest in the Union Pacific Railroad. They became involved in a financial scandal in which U.S. taxpayers were bilked out of millions, and then in the 1870s they died. To cleanse their reputation, officials of the railroad ordered the pyramid built in the brothers' honor at a stopover along the line. The company spared no expense, even unto commissioning the prominent sculptor August St. Gaudens, whose masterworks include figures of everyone from Lincoln to the goddess Diana, to fashion large portraits of the brothers to be embedded in the pyramid. The final tab was $65,000, and a sign at the structure's base bragged that it was "perhaps the finest memorial in America"—a claim that, even back then, was hooey.

Considering the tribute's leaky provenance, it received the fate it pretty much deserved. The railroad went bankrupt in the 1890s, and its successor operation chose a less expensive route through Wyoming, so the pyramid suddenly found itself in the outback. No one really cared about it or cared for it; at some point, both of the St. Gaudens sculptures lost their noses.

Where, by the way, are Oliver and Oakes Ames buried?

Back east.

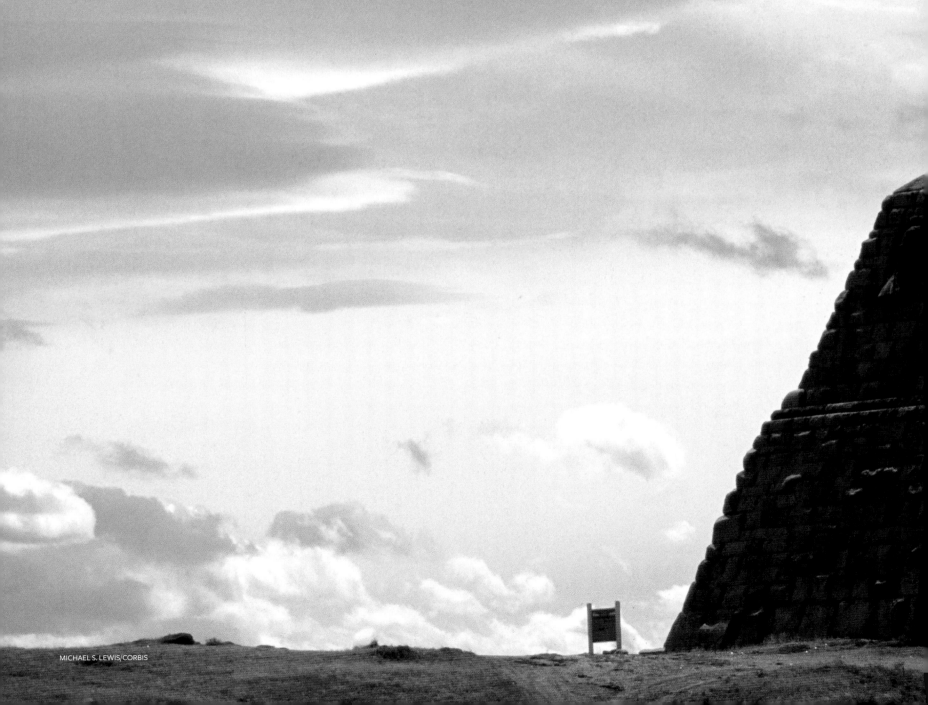

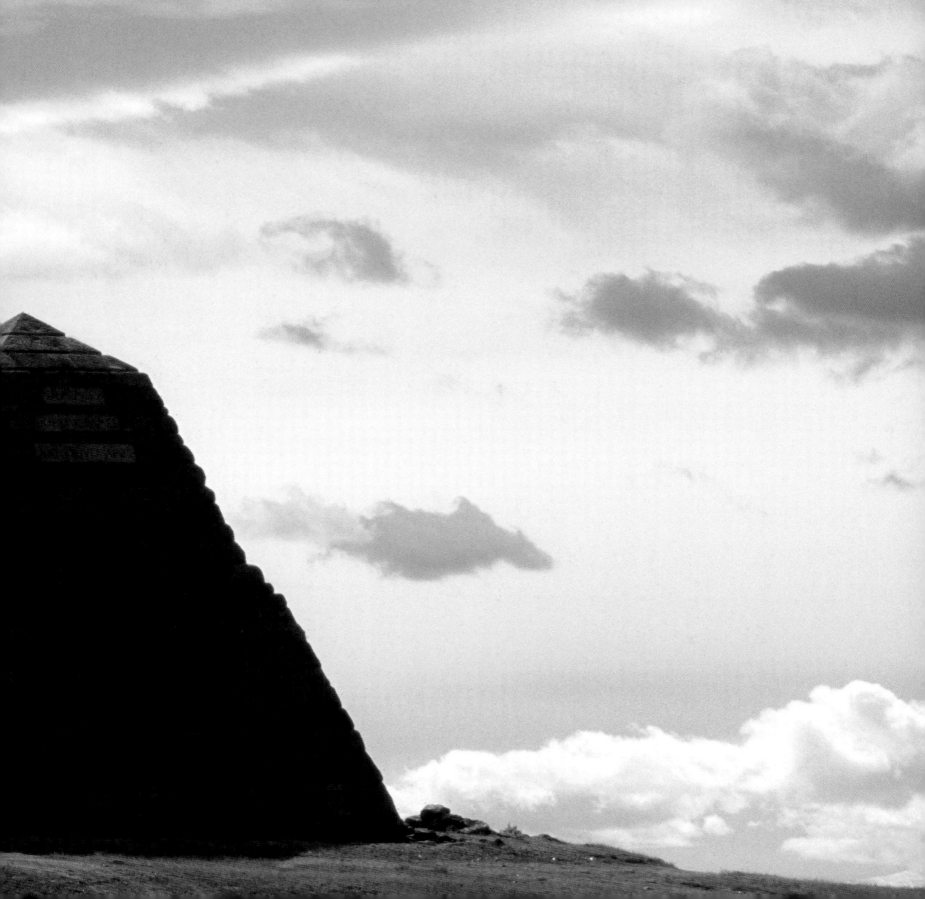

The Rockies Less Traveled

There is no unknown or unhiked stretch of the Rocky Mountains, but there are truly impressive sections that are, for no good reason, less celebrated than others. One of these is the hundred-mile **Wind River Range** in western Wyoming. It doesn't have the biggest this or the steepest that and it's not situated in a national park, and so it goes relatively unnoticed. But trust us: The Winds, large granitic mountains shaped by ice age glaciers beginning 500,000 years ago, are as awe-inspiring as any peaks in the country, including those in the Tetons, Yosemite or Colorado's Rocky Mountain National Park.

As with the mountains in Colorado, the Winds run along the crest of the Continental Divide. More than 40 named peaks reach heights above 13,000 feet, so you're in rarefied air when trekking in this region. The summit of Gannett Peak is the highest point in Wyoming at 13,804 feet, and that's a summit that Rocky fans do try to bag for their life list. In fact, Gannett does feature the one thing in the Winds that is the most-est: Gannett Glacier, flowing off the north slope, is the largest one in the U.S. Rockies at some 900 acres.

But there's so much else here: scores of lakes nestled beneath rugged peaks; circular valleys, including the ethereal Cirque of the Towers; more than 150 other active glaciers on the eastern side of the range, with another 27 on the western slopes. To view the strange, stoic, strong Squaretop Mountain from below, near the shore of one of the Green River Lakes, is an entirely sublime high-country experience.

The best thing about venturing to these less-famous realms in the Rockies is, of course, that you might have them more to yourself than others elsewhere. Go, then, to the Winds—and find your own personal Shangri-La.

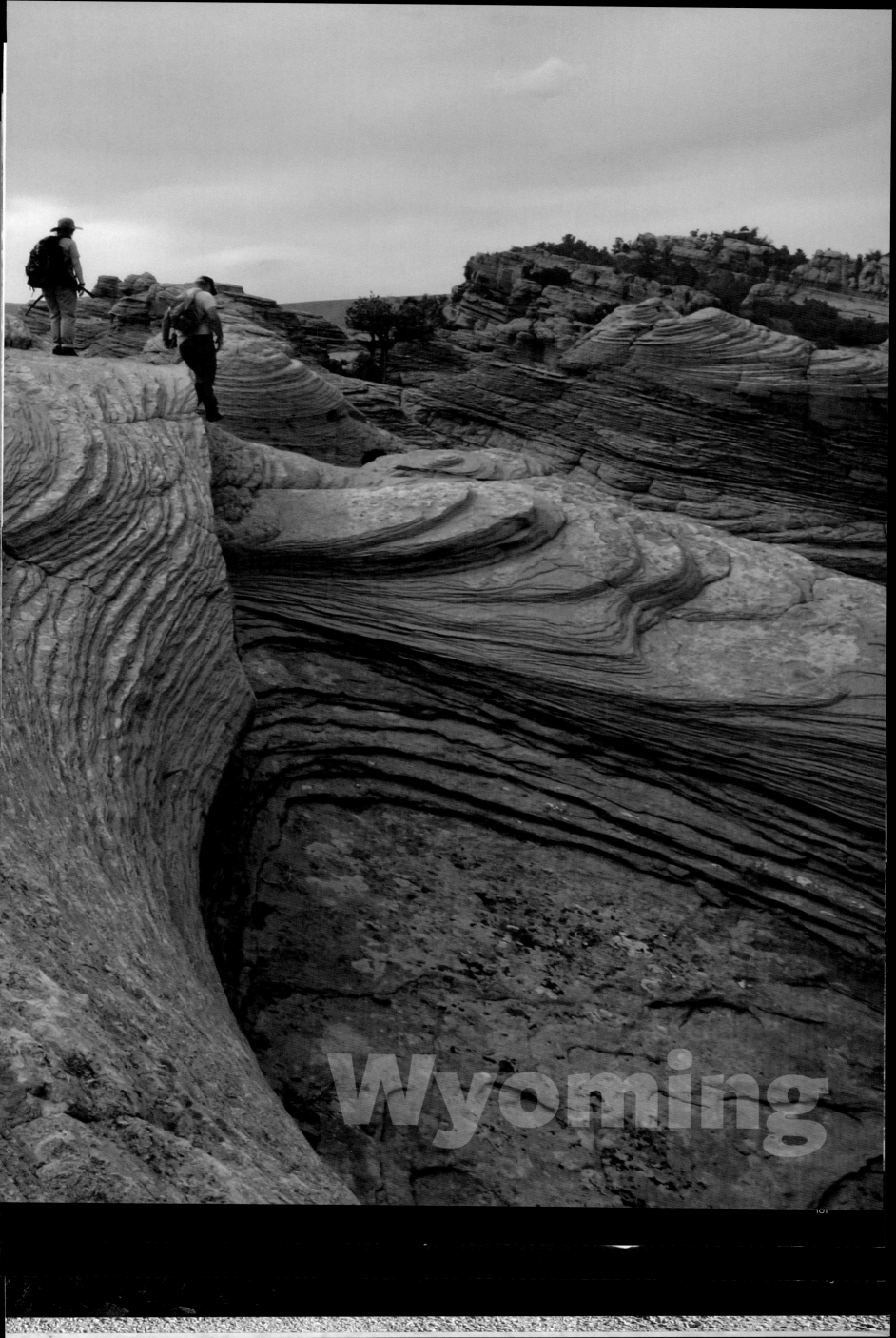

Wyoming

... And Right Next Door

On the pages immediately previous we visited the splendid lakes of northern Idaho. Now we venture due west into Washington, where, on the other side of Spokane, we arrive at the alpine equivalent of those lakes: the **Okanogan Highlands**. Beloved by locals, unknown to most outsiders, modest but nonetheless impressive in scale, the sometimes craggy, sometimes lushly forested Okanogans can be seen as a perfect emblem of the Evergreen State.

One reason the Okanogans tend to get overlooked, perhaps, is that Washington has so many outsize attractions, and something as subtle as sheer loveliness has trouble competing. Consider: Big White Mountain is the highest in the Highlands at 7,595 feet and North Gardner is tops in the Okanogan National Forest at 8,956 feet, but that places Gardner only 23rd on the state's list of big peaks, a list dominated, of course, by awesome Mount Rainier, one of America's signature mountains and undisputed king of the Cascades at 14,411. Washington is famous as well for its wine country, and for many that means the Yakima or Columbia valleys. But since 2000 there have been wonderful grapes grown in scenic vineyards in and just south of the Okanogan County town of Oroville, hard by the Canadian border.

There are charming towns here and constantly beguiling scenery. Drive the Sherman Pass Scenic Byway between Kettle Falls and Republic and ask yourself as you go if you've ever experienced a prettier drive anywhere.

Now then: What about the thrashing, splashing horses on the opposite page? Well, they're part of a much less pastoral pastime in the Okanogans than sightseeing. Each year during the Omak Stampede, the Suicide Race is staged, in which riders spur their mounts down a steep hillside, across the Okanogan River and on to the finish line. Horses have died in the event, and animal-rights activists have screamed in protest, but the Suicide Race goes on—a turbulent tradition in a tranquil locale.

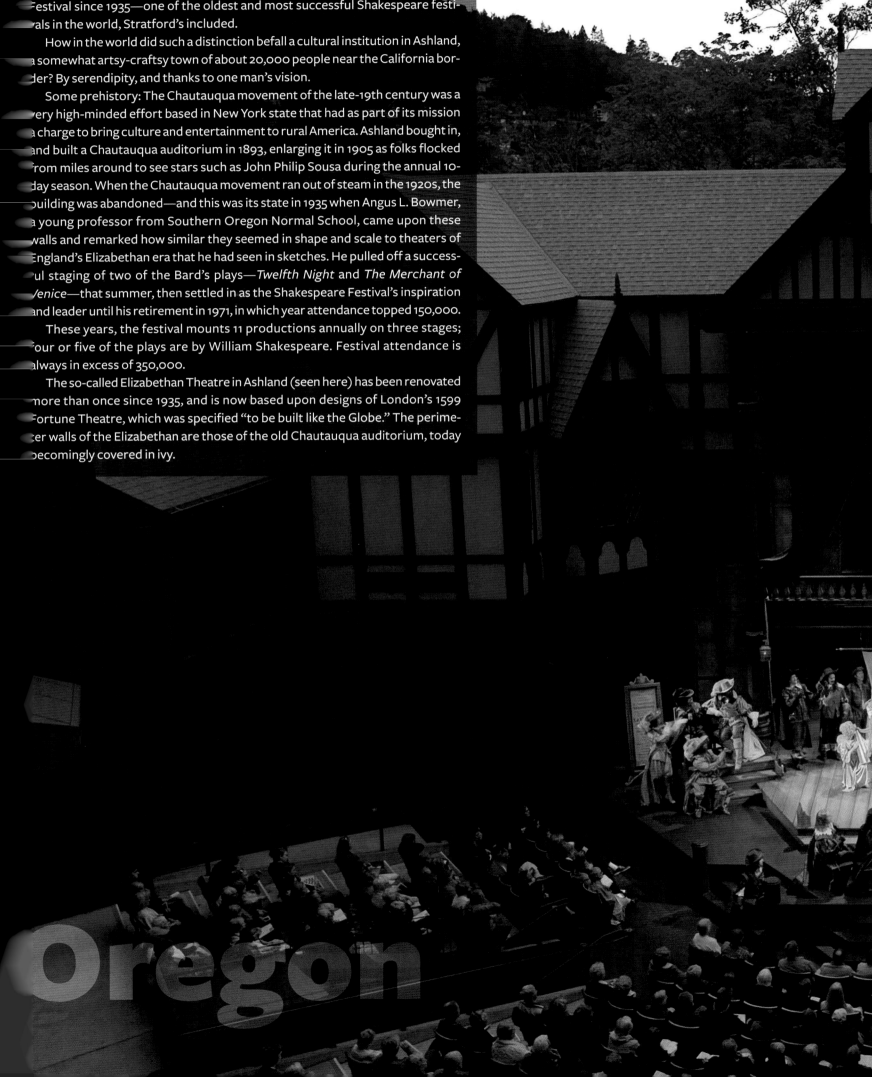

As You Like It

You could certainly brush up your Shakespeare with a sojourn to the source, Stratford-Upon-Avon in England, or a trip to London's Globe Theatre. Or you could go to **Ashland**, home of the Oregon Shakespeare Festival since 1935—one of the oldest and most successful Shakespeare festivals in the world, Stratford's included.

How in the world did such a distinction befall a cultural institution in Ashland, a somewhat artsy-craftsy town of about 20,000 people near the California border? By serendipity, and thanks to one man's vision.

Some prehistory: The Chautauqua movement of the late-19th century was a very high-minded effort based in New York state that had as part of its mission a charge to bring culture and entertainment to rural America. Ashland bought in, and built a Chautauqua auditorium in 1893, enlarging it in 1905 as folks flocked from miles around to see stars such as John Philip Sousa during the annual 10-day season. When the Chautauqua movement ran out of steam in the 1920s, the building was abandoned—and this was its state in 1935 when Angus L. Bowmer, a young professor from Southern Oregon Normal School, came upon these walls and remarked how similar they seemed in shape and scale to theaters of England's Elizabethan era that he had seen in sketches. He pulled off a successful staging of two of the Bard's plays—*Twelfth Night* and *The Merchant of Venice*—that summer, then settled in as the Shakespeare Festival's inspiration and leader until his retirement in 1971, in which year attendance topped 150,000.

These years, the festival mounts 11 productions annually on three stages; four or five of the plays are by William Shakespeare. Festival attendance is always in excess of 350,000.

The so-called Elizabethan Theatre in Ashland (seen here) has been renovated more than once since 1935, and is now based upon designs of London's 1599 Fortune Theatre, which was specified "to be built like the Globe." The perimeter walls of the Elizabethan are those of the old Chautauqua auditorium, today becomingly covered in ivy.

Oregon

OREGON SHAKESPEARE FESTIVAL

Lake of Ill Luck

"God never intended Southern California to be anything but desert," wrote the historian Carey McWilliams way back in 1946, when unnatural changes in the landscape were rampant on a yearly basis. He added woefully, "Man has made it what it is."

What man was doing, in this burgeoning region surrounding Los Angeles, was trying to force the environment to meet his needs. The paucity of water resources had been a nagging concern since the pueblo days of the City of Angels, and it had become abundantly clear that any development in the region ultimately turned on the availability of water. In 1941 the city began to divert four of the five major Sierran streams that fed **Mono Lake**. Without that influx, Mono—one of the oldest lakes in North America, having been formed some 760,000 years ago—dropped by 45 vertical feet and doubled in salinity to three times that of seawater. Consequently, this major breeding ground for waterfowl underwent a 98 percent decline in usage; it remained important to birds in the Great Basin region, but it was no longer the resource and refuge that it had long been.

There is, today, room for guarded optimism regarding the condition of Mono. In the past 30 years, the lake has been a cause célèbre for environmental activists; in one memorable protest, bicyclists lugged water 320 miles from L.A. to make a point. In 1994 legal levels of diversion were set with the goal of "fixing" the lake, and so far the water has risen eight feet, with yet another nine feet to come in order to reach the goal.

As for the otherworldy limestone structures seen here: They are tufa towers. Before L.A. intervened adversely in 1941, they were all underwater.

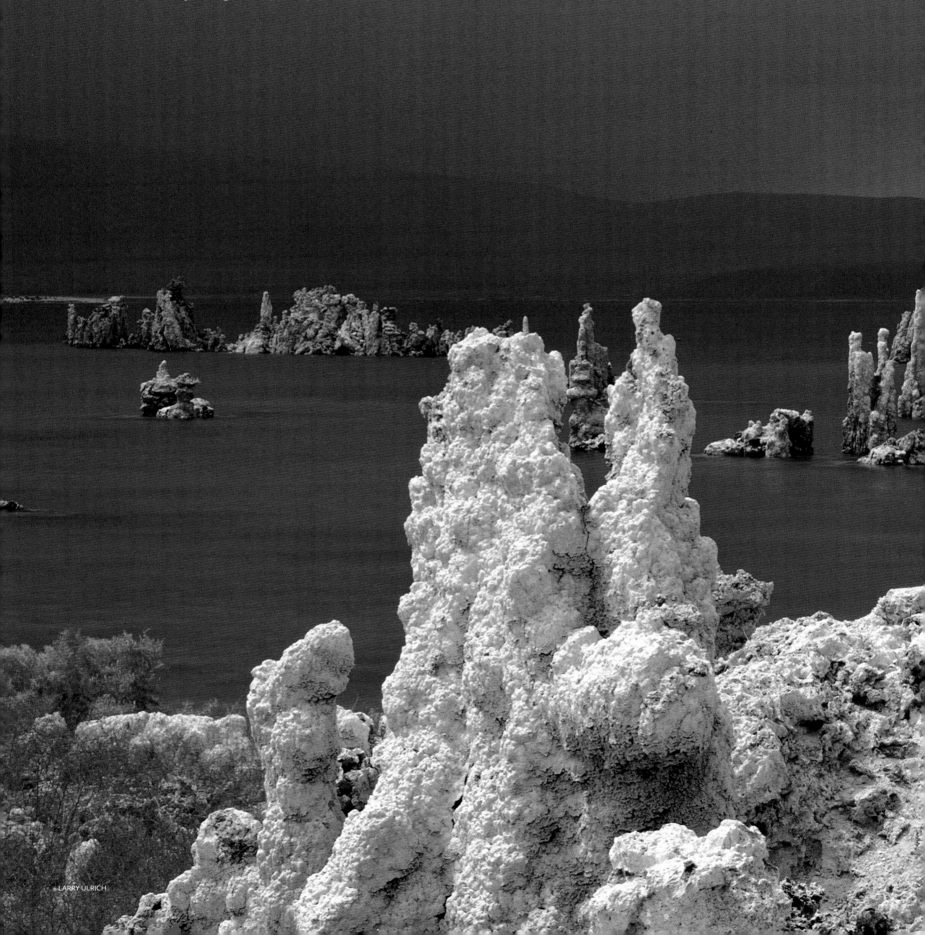

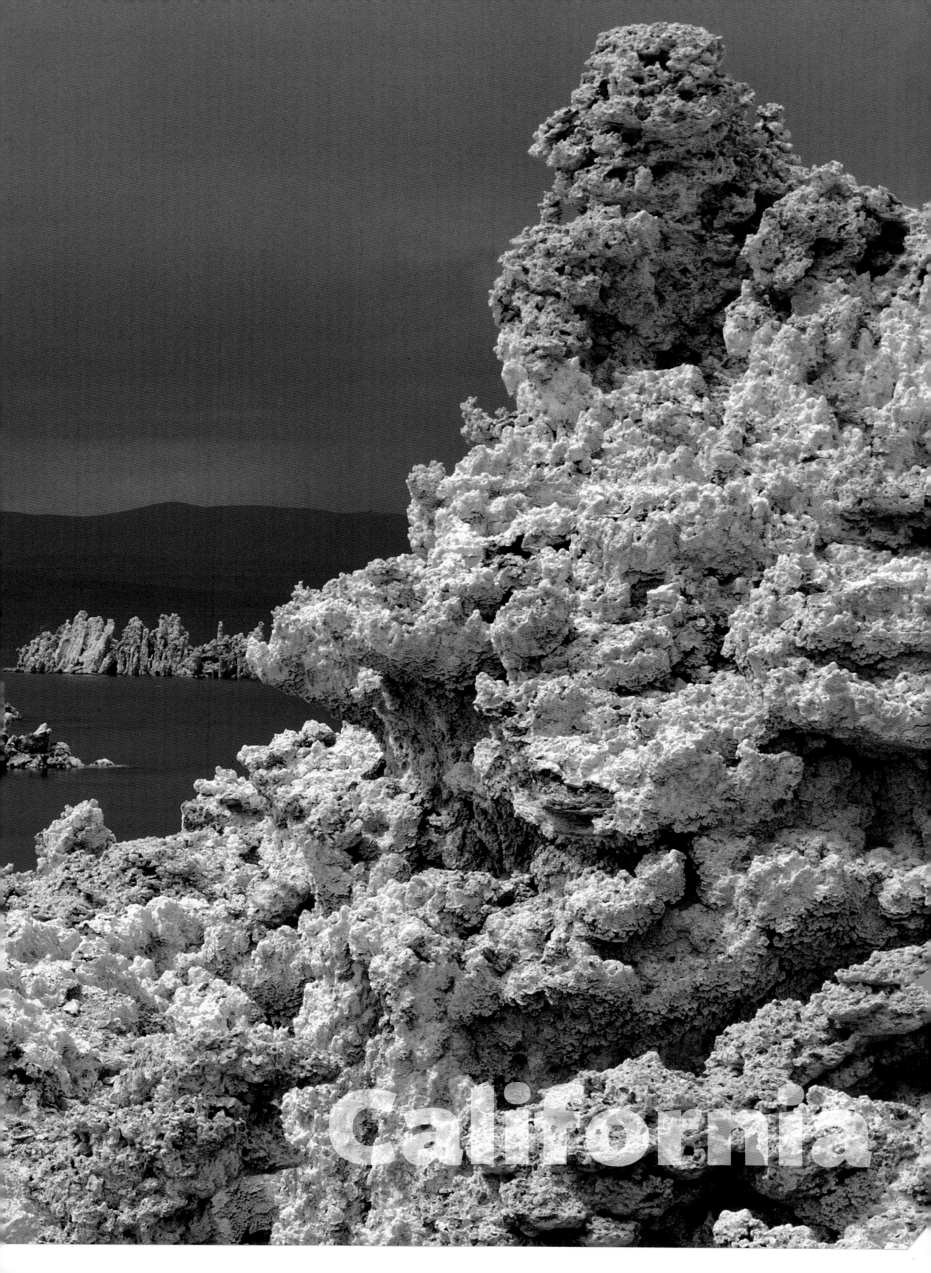

California

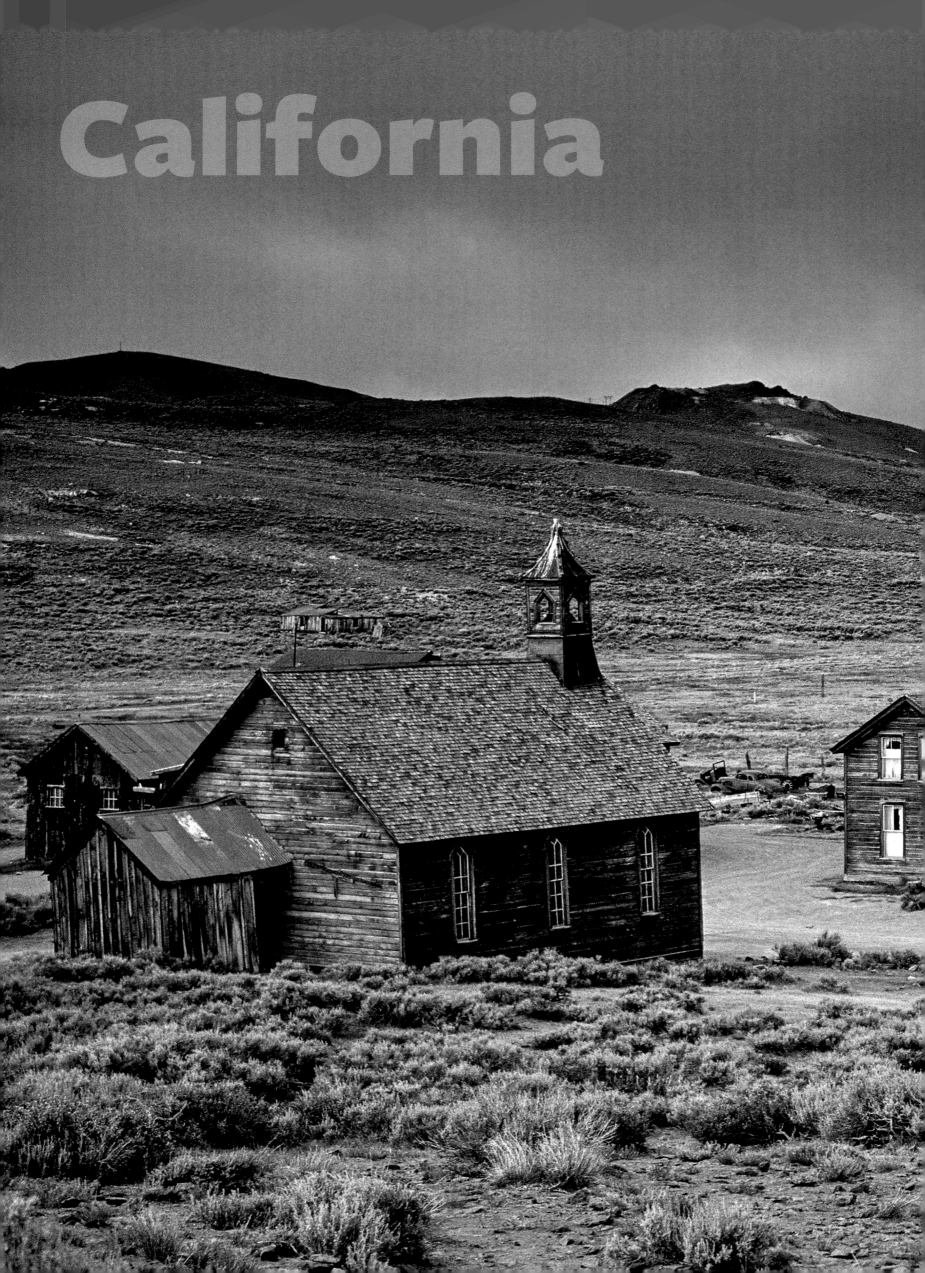

California

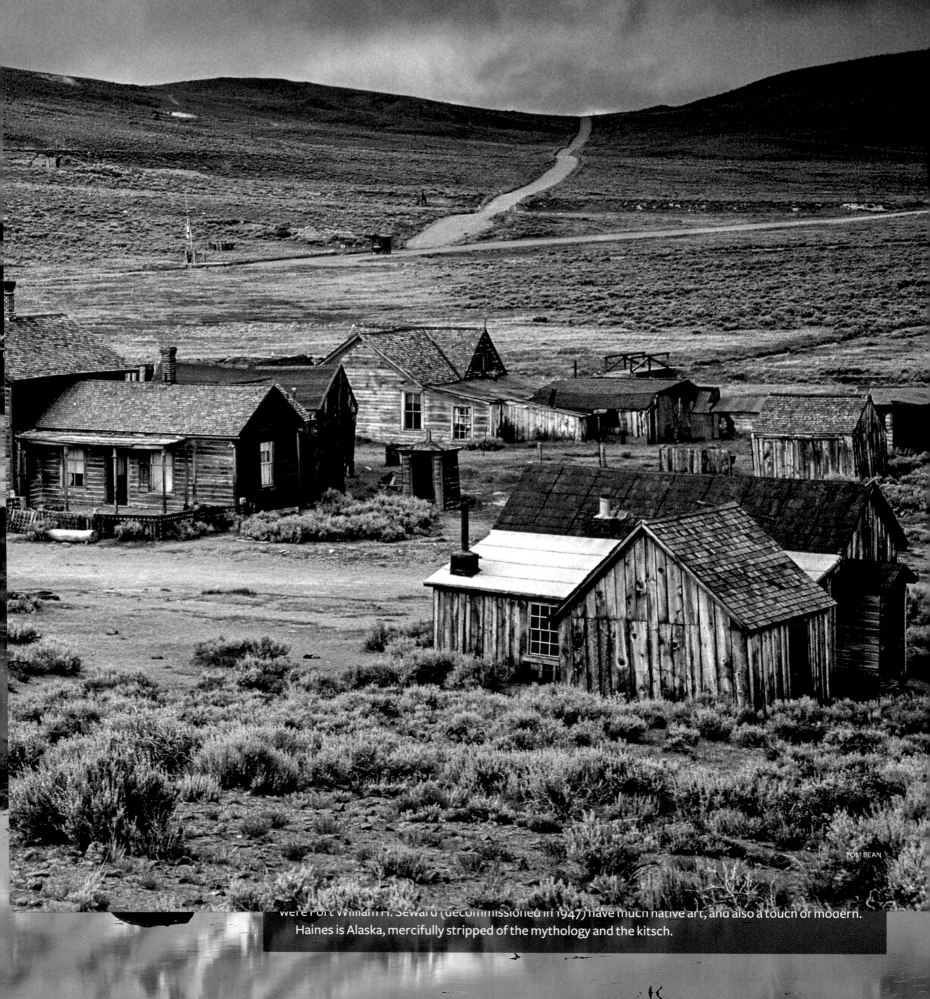

That was once a phrase famous throughout the West; its origin is said to have been the diary of a little girl who had been told by her parents that they were relocating to the notoriously wicked boomtown about 100 miles south of Lake Tahoe. An innocent young girl in **Bodie**? Yikes!

The town was named for one Waterman S. Bodey, alternatively spelled Body but never Bodie; the citizens chose the revised version so that outsiders would pronounce it correctly. Bodey the man was a prospector who struck gold in the area in 1859 but then died in a blizzard before the year was out. Bodie the town was really just a small mining camp for more than a decade thereafter, then it exploded after a much bigger deposit of gold was found in 1876. In its heyday—1879 to 1881—Bodie was bursting on a daily basis with nearly 10,000 people; 2,000 buildings, including 65 saloons serviced by seven breweries, two banks, several newspapers, a well-trafficked jail and numerous whorehouses; a Chinatown neighborhood; and a steady stream of shootings, stagecoach robberies and good old barroom brawls. "A sea of sin," the Reverend F.M. Warrington called it in 1881, "lashed by the tempest of lust and passion."

More than $30 million of gold was extracted from Bodie's mines, and then they were played out. The "most lawless, wildest and toughest mining camp the Far West has ever known" went into a fall as precipitous as its rise, and after a big fire in 1892, the town was just about cooked. The remnant Bodie struggled on for decades, but was finally abandoned in the 1940s.

The California site where Bodie once blazed is now maintained in a state of "arrested decay": The buildings are kept as they were, but there's no paved road to get there, no tourist trinkets, no McDonald's. There is an undeniable poignancy to this. For a little more than three years, Bodie was the very quintessence of a lawless Wild West boomtown. The 10 percent of it that remains today is the very quintessence of a ghost town.

TOM BEAN

were Fort William H. Seward (decommissioned in 1947) have much native art, and also a touch of modern. Haines is Alaska, mercifully stripped of the mythology and the kitsch.

Legends

The Menehunes were a magical population of tiny people who inhabited the Hawaiian Islands before human settlers, if you believe the popular folklore. They are said to have built the fishponds in Oahu's Kaaawa Valley and in the area owned by the neighboring **Kualoa Ranch**, which was established in 1850 and is today a dude ranch that will afford you one of the most exceptional vacations you've ever taken.

Hawaiian chieftains were partial to this place, and it is said that more than 400 of them are buried in caves above the ranch (seen here). The ghosts of these dead leaders, as well as those of their warriors, are "night-marchers," who come forth from the caves and proceed to the sea on a regular basis—again, if you believe the local traditions.

What is incontrovertibly true about this part of Oahu is that it is secluded and irresistibly gorgeous—irresistible, certainly, to Hollywood, which has visited here to film parts of *Jurassic Park* and *Pearl Harbor* among many other movies, as well as the TV shows *Hawaii Five-O* (of course), *Magnum P.I.* and *Lost*. This reputation as a cinematic backdrop is substantial, certainly, but not close to being Hawaii's strongest. Another place on another island was the stand-in for Bali Hai, author James A. Michener's legendary island of innocence and happiness in *South Pacific*.

This utopia was in fact based on the very real, non-Hawaiian island of Ambae, elsewhere in the Pacific. But when it came time to film the 1958 movie of the hit musical, the moviemakers headed to Kauai. There, on Lumahai Beach, Mitzi Gaynor as "Nellie" sang "I'm in Love With a Wonderful Guy," Tunnel's Beach was used for "Nurse's Beach" and, when Juanita Hall as "Bloody Mary" sang wistfully of Bali Hai, she was actually at **Hanalei Bay**—where this sea turtle (opposite) makes his way ashore.

You can revisit legends both ancient and relatively contemporary on these islands, and choose what truth you will.

Hawaii

"The Grand Canyon of the Pacific"

That is what Mark Twain called **Waimea Canyon**, and if any other place in America can rival Arizona's marvelous gorge for heart-stopping beauty, it is indeed this. Waimea (seen here), not only the most dramatic but the largest canyon anywhere in the Pacific, dominates the west side of the island of Kauai. Consider: The entire island is only 26 miles across and 21 miles north to south, yet Waimea is 10 miles long. It is also a mile wide and more than 3,500 feet deep.

The colors here are kaleidoscopic—red, purple, blue, gray, green—and the vegetation is equally multifarious, with mosses, ferns and trees joined by lovely wild orchids and other vibrant flowers. This is an entirely different ecosystem from that in the Arizona desert. Mount Waialeale, the island's central peak, is one of the wettest spots on earth, receiving about 427 inches of rain per year, and the torrents running off its slopes, which for hundreds of thousands of years have carved the canyon, nourish Waimea's plant life.

There are numerous scenic outlooks off the Waimea Canyon Road, but it is a descent into the canyon on one of the hiking trails that provides a once-in-a-lifetime thrill. You'll see, at intervals, goats seemingly clinging to the sheer canyon walls, and brilliant birds flying overhead.

We have visited other places in America that call themselves, or are called by others, "a paradise." To no other locale, however, can this term be more aptly applied than to Waimea.